Captain
William Hilton
and the
Founding of
Hilton Head
Island

Captain William Hilton
and the Founding of Hilton Head Island

Dwayne W. Pickett

Published by The History Press
Charleston, SC
www.historypress.com

Copyright © 2019 by Dwayne W. Pickett
All rights reserved

First published 2019

Front cover. 1711 map by Crisp, Nairne, Harris, Maurice and Love showing Hilton Head Island by its current name. *Courtesy of the Library of Congress.*
Back cover, top. 1667 engraving showing the indigo making process in the West Indies. *Courtesy of the Library of Congress.*
Back cover, bottom. 1862 photograph of slaves of Confederate general Thomas F. Drayton on his Hilton Head Island plantation. *Courtesy of the Library of Congress.*

Manufactured in the United States

ISBN 9781467141918

Library of Congress Control Number: 2019935365

Notice: The information in this book is true and complete to the best of our knowledge. It is offered without guarantee on the part of the author or The History Press. The author and The History Press disclaim all liability in connection with the use of this book.

All rights reserved. No part of this book may be reproduced or transmitted in any form whatsoever without prior written permission from the publisher except in the case of brief quotations embodied in critical articles and reviews.

To my loving family, who gave me support and encouragement.

Contents

List of Figures	9
Preface and Acknowledgements	11
Introduction	13
1. Immigration, Early Life and Marriage	15
2. Shipping Business and Trade with Barbados	25
3. "Set Forth" to Explore the Carolinas	36
4. Indians, Spaniards and Castaways	45
5. Settling the Carolinas	62
6. The Founding of Hilton Head Island: The Early Years	79
7. The Founding of Hilton Head Island: From Royal Colony to Resort	97
Epilogue	117
Notes	121
Index	137
About the Author	143

List of Figures

1. New England coast, 1702. 22
2. Ligon map of Barbados, 1657. 26
3. Hinton engraving of sugar production, 1749. 31
4. The triangular trade between New England, Africa and Barbados. 34
5. Reproduction seventeenth-century ketch. 38
6. Lodge and Bew map of the Cape Fear area, 1781. 41
7. Boss, Brailsford and Hodgson map of St. Helena and Port Royal Sounds, circa 1771. 48
8. Moll map of Port Royal Sound, 1732. 57
9. Schroeter facsimile map of the 1664 Charlestown settlement in the Cape Fear area, 1666. 66
10. Map based on the 1728 survey of Gascoigne and Cook, 1773. 88
11. Crisp, Nairne, Harris, Maurice and Love map showing Hilton Head Island by its current name, 1711. 90
12. Another map based on the 1728 survey of Gascoigne and Cook, 1773. 95
13. An engraving of the indigo making process in the West Indies, 1667. 101
14. Cook map of Hilton Head Island, 1766. 103
15. Ruins of Baynard Plantation house, built sometime in the 1790s. 112
16. Baynard Mausoleum, built in 1846 at the Zion Chapel of Ease. 112
17. Colton map showing the Battle of Port Royal Sound, 1861. 115
18. Slaves of Confederate general Thomas F. Drayton on his Hilton Head Island plantation, 1862. 115

Preface and Acknowledgements

In 2013, during the 350th anniversary of Captain William Hilton exploring Port Royal Sound, I decided to do some research into William Hilton. The purpose of this research was to see if I could acquire enough information to be able to portray Captain Hilton as a living history character. As it turned out, I was able to find a wealth of information not only about William Hilton and his family but also about his involvement in trading with the West Indies and his explorations along the Carolina coast.

At this time, my mother was portraying Eliza Lucas Pinckney, and seeing her success with her character spurred me on to portray Captain Hilton. I wanted to be able to relay the information I had found to adult and school groups in order to enlighten them about the person for whom Hilton Head Island is named. Since I had all this information, I decided that it was enough to be able to write a book about Captain Hilton's life and times and combine it with a history of Hilton Head Island.

Quoted material from documents produced in the seventeenth and eighteenth centuries is used throughout the book, and these excerpts have been kept as close to their original forms as possible. During this period, there was no standardized spelling. People spelled words phonetically and would sometimes spell the same word differently in the same paragraph. Also, there was no standardized grammar or punctuation. Nouns were sometimes capitalized in the middle of sentences, and verb usage was not always consistent. Illegible or missing words and letters from the original documents or an explanation of a

Preface and Acknowledgements

word or event have been added and enclosed in brackets []. Words in parentheses () are original to the documents.

Before 1752, the New Year began on March 25 instead of January 1. If something took place on January 31, 1662, it would actually have occurred on January 31, 1663. In order to avoid this confusion, all the years cited in the book before 1752 have been changed to correspond with modern usage.

This book would not have been possible without the help of several people and organizations. The Heritage Library was helpful in allowing me access to its collections in order to conduct research. Also, the Coastal Discovery Museum has been instrumental in allowing me to portray Captain Hilton and tell his story to numerous students who come there on field trips. I would like to also thank Patsy Deer for putting me in touch with the publisher and Diana Luellen for helping me with my research at the Heritage Library. My mother, Margaret Pickett, was very helpful and read over versions of my research and made herself available to discuss my ideas. Susan, my wife, was patient and supportive of my efforts, and without her support, this book would not have been possible. Lastly, I would like to thank my daughters, Rachel and Ava, who were also supportive and have been to a number of my programs where I portrayed Captain Hilton and were not too embarrassed to see their dad dressed like a seventeenth-century explorer.

Introduction

Hilton Head Island is one of the top vacation destinations in the United States, which is why it attracts over two million visitors each year. But amid the miles of pristine beaches, world-class golf courses, tennis courts, restaurants, shopping and nature, there also is something for the history lover to enjoy as well. From Native American shell rings to Civil War earthen forts, there is much to explore.

By 1526, the Spanish were calling this area Santa Elena. In 1562, the French gave Port Royal Sound its current name and built a short-lived fort on nearby Parris Island. But it was the English exploration of this area in 1663 that would give Hilton Head Island its name.

Most people assume that the name Hilton Head Island has some connection to the Hilton Hotel chain that was founded by Conrad Hilton in 1919. The truth is that the island was named after Captain William Hilton (no relation to Conrad Hilton), a mariner who was born in England in 1617 and lived in Charlestown, Massachusetts. He was hired by a group of gentlemen on the island of Barbados in 1663 to find new lands for them to settle. It was during his exploration of the South Carolina coast that he sailed into Port Royal Sound and was so captivated with it that he decided to write a detailed description of how to navigate it. One of the navigation markers he used was a high bluff of land located on an island at its entrance. He named that high bluff of land *Hiltons Head*, or *headland*, so that anyone who wanted to sail into the sound could see it and know how to navigate it safely.

Introduction

Not only was Port Royal Sound one of the best natural harbors Hilton and his crew had seen, but they also wrote that "the air is clear and sweat" and the "country very pleasant and delightful."[1] This description is as true today as when it was written over 350 years ago. Over the ages, many people, from early Spanish, French and English explorers to modern visitors, have been attracted to this area and enchanted with its natural beauty.

Little has been written about Captain Hilton except for brief mentions about how he named the high bluff of land Hiltons Head along with some quotes and discussion from the published account of his expedition. His life in New England, subsequent involvement in the sugar trade in Barbados and the exploration of the Carolina coast took place during a time of great change in the seventeenth century. Those changes not only affected the development of Hilton Head Island but also the people who did and would call this area their home.

1

IMMIGRATION, EARLY LIFE AND MARRIAGE

On June 22, 1617, William Hilton Sr. and his wife left their home in Northwich, England, and brought their newborn son to Witton Church in the center of that town. It was an exciting day for the Hiltons, as they were about to have their first-born son, William Hilton Jr., baptized.[2] His parents were no doubt anxious about his survival; the previous year, their daughter Elizabeth had died before she was a week old. This was not an uncommon occurrence during this period. The crowded and unsanitary conditions that existed in cities like Northwich resulted in a high rate of child mortality. It has been estimated that about a third of the children in seventeenth-century England died before they were fifteen years old.[3] The Hiltons were no doubt relieved when William Hilton Jr. survived and also thankful that his sister Mary, who was born the following year, lived.

William Hilton Sr. wanted to make a better life for himself and his family, so he decided to head to the New World in 1621. His choice of English colonies at that time was limited to just three viable colonies: Jamestown, which was founded in what is today Virginia in 1607; Bermuda, which was established in 1612; and the Plymouth Colony, which was founded in 1620 in what is today Massachusetts. He decided to head to the newly settled Plymouth Colony. This choice might have been due to his interest in the fishing industry. William Hilton Sr.'s brother Edward, who would also come to the New World, was a fishmonger in London, and it is possible that William Hilton Sr. was one too. It is likely that William Hilton Sr. was interested in settling where he and his brother could continue procuring and selling fish.[4]

When William Hilton Sr. left England, he did not take his family with him. In fact, most of the thirty-four people who sailed with Hilton were traveling alone, and only a few brought their wives and children. He, like the others, no doubt wanted to explore the opportunities available in the new colony. If conditions were suitable, families could always be brought over at a later time.

The Plymouth Colony was founded by a group of settlers that included religious dissenters referred to as Pilgrims. Because they believed the Church of England could not be reformed, the Pilgrims wanted to separate from the established church. For that reason, they were often referred to as separatists. In 1608, prior to settling in the New World, they had sought to make a home in the Netherlands. However, they eventually decided that the Netherlands was not the best place for them. Most of the Pilgrims were farmers and had difficulty finding adequate farmland in the Netherlands. They also were afraid that their children would lose their English heritage and adopt Dutch customs and language. In addition, the Netherlands was a country that tolerated diverse religious sects, and the Pilgrims did not want their children exposed to other faiths. They needed a place where they could worship as they wanted without interference. The colony of Virginia offered them an opportunity to do that.[5]

On April 10, 1606, King James I granted a charter to a group of men to form a joint-stock company, the Virginia Company. This charter established one company with two branches, the Virginia Company of London and the Virginia Company of Plymouth. Both had the right to settle and develop the land in North America known as Virginia, which included all the land between Spanish Florida and French Canada (Cape Fear in present-day North Carolina to modern Halifax, Nova Scotia). The London Company was given the right to settle the land to the south, and the Plymouth Company had the right to settle the land to the north. Since there was a portion of the territory that overlapped, a buffer zone of one hundred miles was to be left between the settlements.

The London Company settled Jamestown, Virginia, on May 14, 1607, and it became the first permanent English settlement in North America. A few months later, in August the Plymouth Company founded the Popham Colony at the mouth of the Kennebec River in Maine. It did not last long, and in the fall of 1608, it was abandoned.[6]

In 1617, the London Company was in deep financial difficulty. In order to raise money, the leadership decided to sell special patents for what was called "particular plantations." Particular plantations were independent

settlements that were not part of the Virginia Company. However, they were required to pay taxes to officials in Jamestown who were under no obligation to help them out financially. The idea of living in an area where they would be able to govern themselves greatly interested the Pilgrims.

On February 2, 1620, the Virginia Company of London granted a patent for a particular plantation to John Peirce, who represented a group of merchant adventurers, for a Pilgrim settlement. A ship called the *Mayflower* was hired to take the settlers to Virginia. Out of the 102 passengers, only about 30 were Pilgrims. The ship went off course, and instead of landing farther south, it arrived off the coast of Cape Cod in what is today Massachusetts, which was outside the jurisdiction of the London Company. Since the Plymouth Company had gone out of business, the area the settlers were in was under the control of the Council for New England. It was decided that instead of moving south into areas controlled by the London Company they would apply for a patent from the Council for New England and stay where they were. That patent was granted the following year, in 1621.[7]

In that year, the ship *Fortune* arrived in the Plymouth Colony with 35 new settlers, including William Hilton Sr. No doubt excited and anxious to begin making a life for himself and his family, Hilton was likely dismayed when he discovered that about half of the original 102 settlers were already dead. The ones that were alive were in desperate need, and when the *Fortune* arrived, they thought relief was in sight. To their astonishment, the *Fortune* was not carrying any additional supplies. Now with more people to feed, rations were cut in half, and the *Fortune* was ordered immediately back to England with trade goods. The ship was loaded with "good clapboard as full as she could stow" and two large wooden barrels, called hogsheads, of beaver and otter skins.[8] Hilton must have thought that coming to the New World was a big mistake, but he persevered and tried to make the best of the situation.

He and the other passengers on the *Fortune* were assigned communal land to farm. At this time, no land was privately owned. The settlers simply rotated farming the common land, and whatever they grew would be shared with the rest of the colony. This system did not work well, and young men began to refuse to work since all of the proceeds from their labor would be divided up.[9] Whether this mindset was shared by Hilton is not known, but he might have had thoughts of moving to another area where he could work for himself, possibly in the fishing industry.

Having established himself, Hilton wrote a letter to his cousin in England and described the condition of the settlers when he arrived. He stated that

they found the "planters in good health, though they were sick and weak, with very small means." He went on to describe in glowing terms the variety of wildlife and sea life as well as plants and trees and asserted that no better grain could be found than Indian corn. His description, while interesting, is no doubt an exaggeration of conditions in the colony and was likely used as propaganda to entice others to come, which is why John Smith had it included in his book *New England's Trials*. At the end of his letter, Hilton stated, "I desire your friendly care to send my wife and children to me, where I wish all the friends I have in England the best; and so I rest."[10]

In 1623, Hilton's wife and two children left England and set sail for their new home. William was just six years old at the time and Mary only four. They boarded either the *Anne* or the smaller accompanying ship, the *Little James*, and between the two ships, there were about ninety passengers, including many of the wives and children of men who had arrived earlier like William Hilton Sr.[11] Since he was only six years old, William Hilton Jr. was probably excited about the adventure he was about to undertake. Because this was his first time on a ship and the fact that passengers would have been required to stay below deck most of the time, he might have gotten seasick like a lot of other people no doubt did. But he might also have been taken with the sea, and this experience might have spurred him on later in life to become a sea captain.

When Hilton's wife and children arrived in 1623, the idea of farming communal land had been discontinued. Instead, the settlers were assigned their own plots of land to farm, but they technically did not own them. Some of those who arrived on the *Fortune*, including William Hilton Sr., were assigned land that "lye to the sea, eastward." For his wife and two children, he was allocated three acres that "but against the swampe & reed-ponde."[12] It was not until 1627 that land was privately owned. At that time, a group of colonists consisting of the Governor William Bradford and four others assumed the colony's debt in return for a monopoly of the fishing industries and fur trading.[13]

Probably sometime in 1624, William Hilton Sr.'s wife gave birth to their third child, a son named John. The Hiltons wanted to have John baptized, but the only church in the colony was the Church of Plymouth. They were not members but brought John there anyway. Despite the Hiltons not being members, the Reverend John Lyford baptized John, which was the "first occasion of the quarrel" between the reverend and the Pilgrims. Lyford ended up being kicked out of the colony along with John Oldham for secretly sending letters back to England disparaging the government in Plymouth.[14]

Captain William Hilton and the Founding of Hilton Head Island

Around this time the Hiltons left the Plymouth Colony and settled along the Piscataqua River in what is now New Hampshire at Dover Point. It is not known if the baptism incident prompted them to leave or if they were already planning to move. William Hilton Sr.'s brother Edward had already established himself in that area, which might have been why they chose to move there.[15] They apparently did not stay at Dover Point long but moved to land Hilton acquired across the Piscataqua River in what is today Maine. He purchased a cornfield and the land around it from the Native Americans.

In 1630, a larger Puritan migration would begin under the leadership of John Winthrop, the Great Migration. This group obtained a royal charter as the Massachusetts Bay Company and established a settlement on the coast just north of Plymouth. They named it Boston after the town of Boston in England. The Puritans, unlike their Pilgrim neighbors to the south, did not seek separation from the established church.

These colonists would expand into the interior and create new settlements in the 1630s and '40s. To the northeast, some Puritans would settle along the coast of New Hampshire and Maine, where they coexisted with other non-Puritans, mostly fishermen like the Hilton brothers. Southeastern New England would become a haven for especially radical Puritan separatists who settled around Narragansett Bay in independent towns that would eventually become the Rhode Island Colony. At the other extreme, some conservative Puritans would proceed southwest to found the colonies of Connecticut and New Haven. However, Massachusetts would remain the most populous and powerful of the New England colonies.[16]

William Hilton Jr. was seven years old when his family moved from the Plymouth Colony and would spend eight years growing up along the banks of the Piscataqua River. He no doubt observed and even possibly worked with his uncle and father in their fishing business. He might have even joined them on small fishing boats as they went out to sea in search of that day's catch. As to his education, William Hilton Jr. benefited from the fact that both his father and uncle could read and write, and undoubtedly his father made sure that his son would be able to do the same. He might have also been introduced to the workings of a ship around this time and might have later studied navigation and cartography.

In 1632, when Hilton Jr. was fifteen years old, the Hiltons were forced to move. At that time, Captain John Mason and his friend Sir Ferdinando Gorges shared a large land grant that included the present-day boundaries of Maine and New Hampshire. They started the Laconia Company and

claimed their charter granted them land on the east side of the Piscataqua River, where the Hiltons were living.[17]

The Laconia Company's goal was to control the fur trade by locating and exploiting the mythical Lake of the Iroquois, reputed to be full of beaver. By 1634, the Laconia Company had gone bankrupt, having tried several times to find the Lake of the Iroquois. Apparently, the supply of furs in the area around the Piscataqua River was not enough to keep the company going.[18]

Although the Hiltons had no recourse but to give up their land, they would have their day in court when Maine came under the jurisdiction of Massachusetts in 1652. On October 25, 1653, William Hilton Sr. was awarded £160 from the estate of the late Captain John Mason; his wife, Ann Mason, was executrix. This sum included compensation for destroying the Hiltons' house and interest on the property for twenty-one years.[19]

William Hilton Sr.'s brother Edward also did not fare well in 1632. For in that year, some Puritans convinced him that his ownership of land at Dover, or Hilton's Point, might be overturned since the charter for Massachusetts overlapped in certain areas in New Hampshire. Edward sold Hilton's Point to a group of Puritan investors who then founded the town of Dover.[20]

In 1636, when William Hilton Jr. was nineteen, he and his father were granted land in what would become Concord, New Hampshire. They acquired the land from a Pennacook Indian named Sagamore Tahanto, but it does not appear that they lived there. William Hilton Jr. described this land grant in a 1660 court petition when he asked the court to confirm it. His petition stated in part:

> *William Hilton having much intercourse with the Indians by way of trayed & mutual giving & receiving amongst whom one Tahanto, Sagamore of Penacooke for divers kindness received from yr petitioners's Father & himself did freely give unto ye aforesaid William Hilton Seniour & William Hilton Juniour six Miles of Land lying on ye River Penneconaquigg being a rivulette running into Penacooke River to ye eastward ye said Land to be bounded as may bee most for ye best accommodation of yr sd petitioner his heyeres & assignes.*

In addition, the petition stated that they also received "two miles of ye best Meddow land lying on ye north east side of ye River Penacooke."[21]

It seems the Hiltons had a good relationship with the Native Americans in the area and they traded mutually with one another. This good relationship was evident when William Hilton Sr. wrote a letter in 1637 to Governor

John Winthrop. In it, Hilton asked the governor to receive into the colony the eldest son of the sachem, or chief, of the Merrimack River region, who owed a Mr. Vane three skins. The son was afraid to come in and pay since "if hee come in to the bay you will take awey his head." Hilton was writing on the son's behalf to get assurances that no harm would come to him.[22]

The Hiltons seem to have stayed in the Dover area, since in 1644 William Hilton Sr. was the deputy for Dover in the Massachusetts General Court. By June 27, 1648, he was living at Kittery just across the Piscataqua River in what is today Maine and was licensed to have a tavern there and possibly a ferry.[23]

Evidently, Hilton was not a good tavern keeper, since he was "presented for not keeping victual and drink all times for strangers and inhabitants."[24] By November 22, 1652, he was a resident of York in what is today Maine, for it was there that he took the freeman's oath to the Massachusetts Bay government when it was given jurisdiction over that area. He was also an alderman (council member) and a selectman (town official) in York from 1652 to 1654.[25]

There is virtually nothing known about Willian Hilton Jr's mother. She died sometime after they arrived in the colony, and even her name has been lost to history. She was referred to only as Mrs. William Hilton. Sometime in the late 1630s or early 1640s, his father married a woman named Frances, and they had four children together, including another William.

About the time his father remarried, William Hilton Jr. also married and moved to Newbury, Massachusetts. While he was living there, he, like his father, got involved with local politics and was a representative for the Town of Newbury in the General Court in Boston. There is no record of him getting married, but he was married by June 1641, since that is when his first child, Sarah, was born. His wife was Sarah Greenleaf, the eldest daughter of Edmund and Sarah Dole Greenleaf. She was born in Ipswich, England, in 1620 and had eight brothers and sisters; three of whom died before they were adults. The family immigrated to the Massachusetts Bay Colony in 1634 and settled in the newly incorporated town of Newbury, Massachusetts, in 1635. Edmund Greenleaf acquired 122 acres of land there and was an ensign for the town in 1639; in 1648, he was licensed to operate a tavern.[26]

William and Sarah ended up having five children together. Their first child, Sarah, was born in June 1641, Charles in July 1643, Anne in February 1648, Elizabeth in November 1650 and William in 1653.[27] All of their children survived into adulthood, which was more the norm for the New England colonies than England. The less-crowded conditions and the

1. A 1702 map showing the coast of New England and the towns the Hiltons lived in. *Courtesy of Cornell University Library.*

availability of fresh water in New England certainly helped increase the number of children that survived.[28]

Edmund Greenleaf thought enough of his granddaughters Elizabeth and Sarah to include them in his will. He left ten pounds to "my grandchild Elizabeth Hilton" and "to my Grandchild Sarah [Hilton]Winslow five pounds if her father pay me the foure pounds he oweth mee."[29] It seems that William Hilton Jr. owed his father-in-law some money that was not promptly repaid.

What relationship William Hilton Jr. had with his stepmother Frances is unknown, but she seems to have been a spirited individual. On October 16, 1649, Frances was "presented and admonished for fighting and abusing her neighbors with her tongue." At the same time, William Hilton Sr. "was presented for breach of the Sabbath in carrying of wood from the woods and for failing to keep food and drink on hand for strangers and inhabitants." A year later, they were both being sued for slander by George Moncke.[30]

The court found Frances guilty in 1655 of "railing at her husband and saying he went with John his bastard to his three halfe penny whores and that he carried a cloak of profession for his knavery." Her punishment was "twenty lashes upon the bare skin," but upon Hilton's request it was postponed until the court met again, contingent on her good behavior.[31]

In that same year, there was an influenza outbreak, which the Reverend William Hubbard described:

> *In 1655 there was another faint cough that passed through the whole country of New England, occasioned by some strange distemper or infection in the air. It was so epidemical that few persons escaped.*[32]

This outbreak likely claimed the lives of William Hilton Jr.'s father and William's wife, Sarah, who was thirty-five years old when she died. These deaths were no doubt hard on Hilton. In September 1655, perhaps wanting to make a change, Hilton purchased a house and garden in an area of Charlestown, Massachusetts, called Wapping Roe from Ralph Mousall, who was a carpenter. In the deed of sale, it referred to Hilton as a mariner and an "Inhabitant alsoe of Charles Townee."[33] This would seem to indicate that he was already a resident there. It might also indicate a second residence he owned or rented since Hilton's last child born to Sarah was listed as being born in Newbury in 1653.

Four years later, on September 6, 1659, William Hilton Jr. married Mehitable Nowell, and just ten days before the wedding, he sold the property he had purchased from Ralph Mousall to Mathew Price. Mehitable was the sixth child of Increase Nowell and Parnell Gray Nowell and had seven other brothers and sisters. She was born in Charlestown, Massachusetts, on February 4, 1638, and was twenty-one years old when she married William Hilton Jr., who was forty-two. She and six of her siblings were born in Charlestown, the exception being her brother Joseph, who was born in London and died soon after birth.[34]

The Nowells had come to the Massachusetts Bay Colony in 1630 with the Great Puritan Migration. Increase Nowell was named in the Charter for the Colony in 1629, and shortly after the Nowells arrived, they settled in Charlestown and were among the first settlers there. Increase Nowell was the secretary for the colony, the first ruling elder of the First Church in Charlestown, a military commissioner and a magistrate. He died in 1655, possibly from the influenza outbreak that claimed Willian Hilton Jr.'s first wife and father. Increase's probate inventory taken after his death showed he was worth £592, which was a considerable sum.[35]

William Hilton Jr. and Mehitable had five children together, making the total number of children Hilton had with both wives ten. These children were Nowell, born in May 1663; Edward, born in March 1666; John, born in 1668; Richard, born in 1670; and Charles, born in 1673.[36] All of his children by his second wife also survived into adulthood.

While Hilton was enjoying his family life, he was also busy in the shipping business. As a mariner, Hilton, like so many others, would help usher in a new era of trade that would help New England become economically viable. With no real cash crop to export, New Englanders began exporting items such as grain, cattle and lumber to other colonies. At this time, an English colony was emerging in the West Indies that would need these items desperately and would form a unique bond with those in New England.

2

Shipping Business and Trade with Barbados

Beginning around 1640, something was about to take place on the tiny Caribbean island of Barbados that would change the character of British North America forever. Hilton had no way of knowing that the development of sugar, or "white gold," as it was often called, on that island would make a profound difference in his and many other people's lives.

Barbados is the easternmost island of the Lesser Antilles in the West Indies. It measures approximately twenty-one miles long and fifteen miles wide. The Portuguese named the island Los Barbados ("bearded ones") supposedly after the fig trees on the island, which have a beard-like appearance.[37] By the time the English settled the island in 1627, the native population had been decimated by disease and by Spanish slave raids during the sixteenth century.[38]

It was a strange and new environment for the English, and they had to adapt and learn how to best use the land. Sir Henry Colt, writing in 1631, described the soil as "nothing else but loose sand." He went on to say that "your ground which you esteem the best is but the leaves and ashes of your trees. Dig but half a foot deep and there will be found nothing else but clay." But he also thought the "air & soil produceth with a marvelous swiftness" if the people there would apply themselves. He wrote that in his time there, "I never saw any man at work" and that they wasted their time drinking and fighting.[39]

The first crop the settlers tried to grow for export was tobacco, which was already being successfully grown in Virginia and Bermuda. Henry Winthrop, the son of John Winthrop (who founded the Massachusetts Bay Colony in

1630), came to Barbados with the first group of settlers in 1627. He wrote to his uncle back in England in August 1627 that he wanted "to stay here on this iland caled the Barbathes in the West Indyes and here I and my servantes to joine in plantinge of tobaccoe."[40] He also wrote his father about his plans and asked him and his uncle for servants and supplies. In exchange, he promised to send back five hundred to one thousand pounds of tobacco.[41]

John Winthrop did send Henry some supplies, but he did not get a good return on his investment. In a letter to his son dated January 28, 1628, John Winthrop let Henry know that the tobacco he had sent to him and his uncle "was very ill-conditioned, foul and full of stalks and evil colored; and your uncle Fones, taking the judgement of divers grocers, none of them would give five shillings a pound for it."[42] By the late 1620s and early 1630s, tobacco prices fell sharply due to increased production, and the inferior quality of Barbados tobacco made it almost worthless. John Winthrop let his son know that he could not afford to send any more supplies. Henry returned to England and joined his father in founding the Massachusetts Bay Colony in 1630, only to drown two days after arriving while trying to swim across a river.[43]

Since tobacco was not successful, Barbados settlers next tried to grow cotton. By 1635, cotton was thriving, and the population of the island grew quickly. In addition to cotton, some grew indigo plants, whose green leaves were used to make a rich blue dye that was much sought after in the textile industry in England. On top of that, there were some who were growing

2. A 1657 map of Barbados by Richard Ligon. *Courtesy of the British Library.*

ginger as well. However, by the early 1640s, cotton prices had dropped due to overproduction, which left those in Barbados "in a very low condition."[44]

Despite the depressed economic conditions on the island, there was one man who decided to look for a new cash crop to export. That man was James Drax. During this downturn in the economy, Drax set sail for the town of Recife along the coast of the westernmost tip of Brazil to learn how the Dutch and Portuguese produced sugar. He was not only interested in planting techniques but also in the complicated manufacturing process. During Drax's time there, he formed bonds with sugar traders and with merchants and bankers in Amsterdam, which at this time was the sugar refining capital of the world.

By the end of the sixteenth century, there were more than 120 sugar mills along the Brazilian coast, making it the richest European colony in the world. The Dutch, after thwarting Spanish rule, were now entering their golden age. They were very successful bankers and traders and wanted a piece of the sugar trade. To that end, the Dutch West India Company was founded in 1621. The company's main objective was to carry out attacks on Spanish and Portuguese colonies in South America, the West Indies and on the west coast of Africa.

In February 1630, the Dutch captured Recife, and although the fighting resulted in the destruction of a number of sugar mills by the Portuguese so they would not fall into enemy hands, the industry was revived by the Dutch. After 1636, Dutch ships were transporting Brazilian sugar back to Holland and encouraged the plantation owners to reestablish their sugar mills and increase production. The drive to produce more caused a strain on the plantation owners, and cooperation began breaking down. In the early 1640s, there were several bad harvests, and this, compounded with deteriorating cooperation, prompted the Dutch to look for new sources of sugar.

This was the state of affairs when James Drax came to visit Recife, and the Dutch were interested in the possibility of expanding sugar production to the Caribbean. Barbados, like other islands in the Caribbean, was an ideal place for growing sugar cane. The island's proximity to the equator and climate were similar to that of New Guinea, where sugar cane naturally grows.[45]

Although he was not the first person to grow sugar cane on Barbados, James Drax was the one who perfected it. It took him "divers yeeres paines, care, patience and industry, with the disbersing of vast sums of money" to accomplish this.[46] Through trial and error, Drax was able to succeed. Sugar cane, unlike tobacco and cotton, was a time-consuming crop and difficult to grow, and its processing was also problematic. The first crop Drax planted was likely harvested

too soon, and the sugar he got from it was "so moist and full of molasses and so ill cur'd as they were hardly worth brining home to England."[47]

With help from sugar planters in Brazil, he was able to plant his cane better, strengthen the rollers that crushed the cane to extract juice and master the boiling process, which took place in copper pots of various sizes. When his first shipment of good sugar arrived in England, it sold for a higher profit than anything else imported from England's colonies.

Drax began to increase his labor force by purchasing more slaves and using sugar as currency. When the ship *Mary Bonaventure* arrived in Barbados with 234 slaves, he purchased 34 of them and paid for them with sugar and other commodities. With Drax's success, other islanders soon began growing sugar cane, and by 1645, about 40 percent of the island's agricultural area was planted in sugar cane.[48]

This was good timing for those who decided to grow sugar cane, as a rebellion broke out in Brazil in 1645. During this rebellion, cane fields and sugar mills were damaged and large numbers of slaves were able to make their escape. Sugar production there ceased for a year, which caused the price of sugar to skyrocket. Those who produced sugar in Barbados saw enormous profits and accumulated immense wealth, which made Barbados the richest of all the English colonies.[49]

The price of land on Barbados at this time also began to skyrocket. Land that sold for ten shillings an acre in 1640 was now worth ten times that amount in 1646 and sold for five pounds.[50] Since land was so valuable, planters wanted to make sure they maximized their profits and used the land almost exclusively to grow sugar cane, which left very little land to grow food. The need for profit outweighed the need to grow food; after all, food and other supplies could be imported even if they cost more.

In 1647, Richard Vines wrote a letter from Barbados to Governor John Winthrop in the Massachusetts Bay Colony. In it, he informed the governor that

> this gentleman Mr. John Mainford, merchant is coming to your port to trade for provisions for the belly which at present is very scarce…and not that only, but men are so intent upon planting sugar that they had rather buy foode at very deare rates than produce it by labor, soe infinite is the profit of sugar workes after once accomplished.[51]

George Downing, Governor John Winthrop's nephew, spent some time on various islands in the West Indies preaching. In 1645, Downing wrote to his uncle:

> *The certainest commqdityes you can carry for those parts (I suppos) will be fish as mackrill basse, drye fish, beefe porke if you can procure them at reasonable rates, and if you be there in the spring its the best time because the fewest ships are there, linnen cloath is a certaine commodity.*[52]

Mackerel and bass were not the only types of fish that were exported to the West Indies. Hake, haddock, pollock and various grades of cod were also imported. The lowest grade of cod was refuse cod, which was used to feed slaves and indentured servants and was "cod that was broken, undersized, over-salted, left out in the rain, or damaged in any other way," while the highest grade, merchantable cod, was "properly split and cured."[53] Cod, according to Thomas Morton, was a "commodity better than the golden mines of the Spanish Indies."[54]

Not only was grain, bread, beef, fish and cattle sent to Barbados, but boards, timbers, pipe staves (for making wooden barrels), horses and oxen also were imported. Beauchamp Plantagenet wrote in 1648 after a visit to Barbados that "New England sendeth horses and Virginia oxen" to turn the sugar mills there.[55] In that year, Governor Winthrop made a note in his journal about a ship "lying before Charles Towne with eighty horses onboard bound for Barbados."[56]

Trade with Barbados came at a good time for New England. By 1641, the Great Migration of Puritans had slowed, due in part to the onset of the English Civil War, which took place from 1642 to 1651. The people who were already in New England grew a surplus of food to exchange with new arrivals for cash and wares. But when the newcomers stopped coming, this system was no longer viable. There was, however, a strong mercantile and shipping community that could transport agricultural surplus. Governor Winthrop wrote in his journal on June 2, 1641:

> *These straits have set our people on work to provide fish, clapboard, planks etc and to sow hemp and flax (which prospered very well) and to look out to the West Indies for a trade for cotton.*[57]

In addition to supplying Barbados with food, supplies and even clergy, New England also contributed to the labor needed to run the sugar plantations. John Winthrop recorded in his journal on February 26, 1638, that the ship *Desire* had returned from the West Indies carrying "some cotton, and tobacco, and negroes, etc., from thence."[58] Six years later, in 1644, he recorded a ship—carrying pipe staves to trade for slaves—leaving

Boston for the Cape Verde islands off the west coast of Africa. Those slaves were taken to Barbados, where they were traded for wine, sugar, salt and some tobacco.[59]

In the 1640s, the Barbadians were using a combination of indentured servants and Indians as well as African slaves. But as sugar began to thrive, the need for more workers became paramount. While cotton and tobacco required a good labor force, sugar demanded even more.

Planting the sugar cane, weeding, harvesting and protecting it from pests was a labor-intensive effort. The cane also had to be harvested at the exact ripeness during the dry months of January and June, and before the crop spoiled, the juices had to be extracted by crushing the canes in a sugar mill powered by men, horses or oxen. After the juice was extracted, it was taken to a boiling house, where it would be boiled in a series of four to five successively smaller copper kettles. When the juice was in the first kettle, any impurities were skimmed off the top before it went to the next kettle, which was smaller and hotter than the one before it. When the liquid got to the end, the sugar was thick and dark brown in color. Next, quicklime was added to aid in granulation, and just at the right moment, the mixture was placed on a cooling cistern.

If the process went smoothly, a raw brown sugar called *muscovado* was produced along with a liquid byproduct, molasses. The sugar was cured in earthenware pots and the molasses allowed to drain further for up to a month. Then the sugar was allowed to dry in the sun before being sent to Bridgetown, where it was put into hogshead barrels that held about 1,500 pounds of sugar and then exported.[60]

So many things had to go right in order for this process to work, and it required careful supervision. If the cane was not harvested at the right time, if the timing of when it went into the boiling kettles was not exact or if machinery was not properly maintained and failed, a poor end product and a loss of profits could result.

George Downing, in a 1645 letter to his uncle from Barbados, stated:

> *I beleive they have bought this year no lesse than a thousand Negroes; and the more they buie, the better able they are to buye, for in a yeare and halfe they will earn (with gods blessing) as much as they cost.*[61]

In that year, it has been estimated that there were about seven thousand African slaves in Barbados, and ten years later, in 1655, they numbered around twenty thousand.[62]

3. A 1749 engraving by John Hinton showing how sugar was made.
Courtesy of the Library of Congress.

Richard Ligon traveled to Barbados in 1647 and spent three years there. He arrived just when sugar was taking off and witnessed the changes it brought. When he returned to England, he published an account of his time there, *A True and Exact History of the Island of Barbados.*

He arrived in Barbados at a time of great sickness the inhabitants of Barbados called bleeding fever or Barbados distemper. Today, it is known as yellow fever. It has been estimated that about six thousand people may have died out of a population of twenty-five thousand during this yellow fever outbreak.[63] With so many people dead, the land of the deceased came up for sale and was purchased by the rich planters. Small land owners who could not afford to switch to sugar and were not making much money growing cotton, ginger, tobacco or indigo began selling their lands to richer planters as well. These small planters would begin an exodus, with a number of them immigrating to the New England colonies, leaving large amounts of land in Barbados in the hands of sugar barons.

Back in England, low birthrates and an increase in wages, along with a large number of casualties from the English Civil War, created a dearth of willing immigrant labor to Barbados. In the 1630s, some of the poor in England, Ireland and Scotland were willing to become indentured servants in order to make better lives for themselves. They would contract to become someone's servant for a number of years in return for having their passage

paid for and some land and sometimes money to get them started when their service was up. In the 1640s, this all changed, and there were few servants willing to come to Barbados, which caused a shortage in labor at a time when it was needed the most.

In order to make up for this shortfall, prisoners of war, criminals, vagrants and other undesirables were sent. About eight thousand Royalist prisoners from the English Civil War were exiled to Barbados as servants between 1645 and 1650. This rid England of those who supported the king and also made the government money.[64] Criminals were sometimes given the choice of either serving out their sentences or becoming servants in Barbados. Some chose to go to Barbados, but there were some who decided to accept their punishments. One person, "having robbed the Post and so condemned to be hanged would not accept of a reprieve but rather chose to be executed than to be sent into the Plantation of Barbados."[65]

When this was not enough, people were either tricked or forced into servitude. William Bullock, who lived in both Barbados and Virginia, noted that "the usual way of getting servants hath been by a sort of men nicknamed Spirits."[66] Bullock explained:

> *All the idle, lazy simple people they can entice, such as have professed idleness and will rather beg than work; who are persuaded by these Spirits they shall go into a place where food shall drop into their mouths; and being thus deluded, they take courage and are transported.*[67]

Because of this, the word *Barbadosed*, which basically means to be tricked or coerced into servitude, appeared in the lexicon. Being Barbadosed in the seventeenth century was similar to being shanghaied in the nineteenth century.

When tricking and enticing did not work, people, mainly children, were abducted and sold into servitude. Thus, the word *kidnapping*, the nabbing of kids, entered the English language. Its official meaning at the time was "to steal or carry off children and others for service on the American plantations."[68] Distraught parents often never saw their children again, but some were recovered before it was too late.

In his account, Ligon commented at length about the plight of indentured servants as well as African and Indian slaves. He stated that there were three types of people on Barbados: "Masters, Servants and Slaves." In addition, he wrote:

> *The slaves and their posterity, being subject to their Masters forever, are kept and preserved with greater care than the servants, who are theirs but for five years, according to the law of the land. So that for the time the servants have the worser lives, for they are put to very hard labor, ill lodging, and their diet very slight.*[69]

Since slaves were more valuable, masters did not want to work them to death before they could get a return on their investments. Indentured servants, on the other hand, were servants for only a set number of years, meaning that the plantation owner would get a quicker return on his investment and thus would try and get as much labor out of them as they could in a short time.

The treatment of servants, according to Ligon, depended on whether "the Master is merciful or cruel." He went on:

> *Those that are merciful, treat their Servants well, both in their meat, drink and lodging, and give them such work, as is not unfit for Christians to do. But if the Masters be cruel, the Servants have very wearisome and miserable lives.*[70]

If indentured servants survived their terms of service, they were to receive land along with money or goods. With most land being owned by the wealthy, and that available being too expensive, most former servants were forced to leave Barbados. According to a visitor in 1651, once a servant's term was up, he was supposed to receive "10£ Sterling or the value of it in goods if his master be so honest as to pay it."[71] This implies that not all masters paid and servants would be turned loose with virtually nothing.

Despite their best efforts, Barbadian planters were not getting enough indentured servant labor. In order to fill this void, Indian and African slaves were sought. By this time, most of the Caribbean islands were devoid of native people, as the native population had been disseminated through disease and slave raids by the Spanish in the sixteenth century. When Ligon arrived, he noted that "as for the Indians, we have few and those fetched from other countries some from neighboring Islands some from the Main [South America] which we make slaves."[72] The women, he wrote, were good at making bread; cassava, an edible starchy tuberous root; and a drink called *mobbie*, made from a red variety of sweet potato. The men, he stated, were used for footmen and for hunting fish, which they did with their bows and arrows.

With the lack of indigenous people to enslave, the Barbadians began using West Africans. A letter to John Winthrop from his nephew in Barbados described how one would use servant labor until one could afford to buy slaves:

> *A man that will settle ther must looke to procure servants, which if you could get out of England, for 6, 8 or 9 yeares time onely paying their passages, or at the most but som smale above it would do very well, for so thereby you shall in a short tim be able with good husbandry to procure Negroes (the life of this place) out of the encrease of your owne plantation.*[73]

As noted by Downing, these African slaves were "the life of this place," meaning that without their labor, large-scale sugar production would not have been possible. As early as 1636, the governor of Barbados decreed that both Indian and African slaves were to serve for life unless contracted differently.[74]

At this time, the Dutch were the main suppliers of African slaves, but the English, including those in New England, were quick to join in. This trade in people and commodities has been called the triangle trade. For example, some ships from New England would sail to the west coast of Africa with rum, guns, ammunition and other goods such as beads, cloth and copper to trade for slaves. Those slaves were then taken to the islands in the West Indies, especially Barbados, and sold. This part of the trip was known as the Middle Passage, and many slaves died of disease in the cramped, overcrowded ships. Once the slaves were sold, the ships would return to New England with sugar and molasses to sell and make rum, starting the process all over again.

4. Map showing the triangular trade routes between New England, Africa and Barbados. *Courtesy of Wikimedia Commons.*

Richard Ligon described how the slaves were sold once they arrived in Barbados:

> *When they are brought to us, the Planters buy them out of the Ship where they find them stark naked and therefore cannot be deceived in any outward infirmity. They choose them as they do Horses in a Market; the strongest, youthfulest, and most beautiful, yield the greatest prices.*[75]

At the time New England began trading with Barbados in the 1640s, William Hilton Jr. was living in Newbury, Massachusetts, with his wife Sarah and several young children. He no doubt saw what profits were being made in trading with the West Indies and, probably sensing an opportunity to further advance himself, decided to get in on the action.

On December 29, 1649, he sold "James my Indian and all the interest I have in him…to be the aforesaid George Carr his servant forever or to whom the said George Carr shall assign." In exchange for James, Hilton received a quarter of a ship. James apparently consented, willingly or not, to the sale by making his mark on the bill of sale.[76] This is the only reference to William Hilton Jr. owning a slave, but he, like many of his contemporaries, may have owned more.

James might have been taken prisoner and subsequently sold into slavery during one of the several conflicts that took place between the colonists and the Native Americans. The enslavement of Native Americans in New England began in 1636 with the onset of the Pequot War. From 1636 to 1637, Pequot Indians in southern New England fought a war with English settlers from the Massachusetts Bay, Connecticut and the Saybrook colonies and their Native American allies the Narragansett and Mohegan. This resulted in the Pequot retreating from their lands and some of those captured being sold into slavery. Around 180 Native Americans were taken prisoner, with about 20 to 30 of them being executed. The rest of the captives who were not released were given to soldiers, the Narraganset Indians, Massachusetts and Connecticut. Massachusetts was going to send the male children to Bermuda to be sold as slaves, but instead they were sold in the island of Providence off the coast of Nicaragua.[77]

From 1636 until Kings Philip's War in 1675, there were conflicts with different Native American tribes in New England. To address this problem, Massachusetts Bay, Plymouth, Connecticut and New Haven formed a confederation called the United Colonies of New England in 1643. The articles of confederation stated in part that anything taken from the Native Americans in war "whether it be in lands, goods, or persons shall be divided among the said confederation."[78]

How and when Hilton acquired James is unknown, but selling him to George Carr now allowed Hilton to become a part of the trading that was going on with the West Indies. No other information about interest in other ships has come to light, but Hilton eventually acquired his own ship, which was named the *Adventure*. With his own ship and trade having been established with the West Indies, the next phase of William Hilton's career was about to begin.

3
"Set Forth" to Explore the Carolinas

When William Hilton Jr. became part owner of a ship in 1649, he began an incredible journey that would take him from a successful shipping merchant to a well-known explorer. Not much is known about Hilton's shipping activities in the 1650s, but it seems that he prospered, for in 1659, he married Mehitable Nowell, the daughter of the secretary of the Massachusetts Bay Colony. Her family must have considered Hilton prosperous enough to marry her, as consent would have had to be given.

The ship he owned with George Carr was no doubt made by Carr at his shipyard on Carr Island, located in the Merrimac River between the towns of Newbury and Salisbury. With trade opening up with the West Indies, shipbuilding in New England had quickly become a major business. The long coastline in Massachusetts, with its natural bays, was an ideal location for harboring ships. Also, there was an abundance of natural resources in the area, including forests that supplied wood for shipbuilding. Many shipwrights made fishing boats to fish the cod banks that stretch along the edge of the continental shelf from southern New England to Newfoundland, Canada. Others made larger, oceangoing ships for trade with the West Indies. George Carr saw the business potential in shipbuilding and established both a shipyard and a ferry on Carr Island sometime after he acquired it in 1640.[79]

No information about the kind of ship Hilton co-owned with George Carr has survived, but what is known is that Hilton was eventually able to acquire his own ship, a ketch named the *Adventure*.[80] Whether this was the ship he co-owned with Carr or not is unknown, but at this time, ketches

varied from small fishing boats to seagoing vessels over one hundred tons. During this period, tonnage referred to how much cargo a ship could carry, not its weight.[81]

Since the *Adventure* was involved in trade with Barbados, it was most likely one of the larger vessels of one hundred tons or more. There is only one reference to the number of people it carried, and that comes from a 1663 letter that stated the *Adventure* set sail with "twenty two men" onboard.[82] Unfortunately, the letter does not state how many of the twenty-two men were crew and how many were passengers.

Maritime historian Ralph Davis has stated that a 200-ton Virginia trading ship would have had a crew of twenty to twenty-one men in the seventeenth and early eighteenth centuries. He also stated that the average tonnage per crewman for a British ship entering London in 1686 was just under 9 tons per crewman.[83] In 1662, Hilton sailed from New England with five known passengers on his ship. If he did indeed carry a total of twenty-two men on his 1662 voyage like he did in 1663, that would put the number of crew at around seventeen. That would mean the *Adventure* was probably somewhere around 153 tons.

The name *ketch* might have been taken from the word *catch*, since these vessels were often used to catch fish. The ketch was not only used for fishing but also for transporting goods. Larger ketches like the *Adventure* were used to trade with the West Indies and seem to have been a popular choice—along with the sloop—among ship owners in New England. When John Turner, a merchant in Salem, died in 1680, the inventory of his estate showed that he owned or partially owned fourteen ships, most of which were ketches.[84]

The cost to purchase a ketch in the second half of the seventeenth century in New England appears to have varied slightly. In 1666, Jonathan Baulston, shipwright, of Boston, entered into an agreement with Samuel Legg, mariner, to sell one half of a ketch at the rate of £3 8s per ton. William Carr, son of George Carr, agreed to build Robert Dutch, mariner, "a good & substantial Ketch" in 1677 at the rate of £3 5s per ton, with Robert Dutch supplying the ironwork.[85] Given these rates, the *Adventure*, if it was around 153 tons, would have been valued at around £508.

Hilton had a commercial connection with Barbados and traded there, but he might have also visited Bermuda. In 1659, "the ketch Adventure" was listed as calling in Bermuda, and this might have been Hilton's ship.[86] References to Hilton also being in Surinam have been cited in other sources, but they make no mention of where that information came from.[87] Surinam is located on the Atlantic coast of South America, and the governor of

5. Photograph of a reproduction seventeenth-century ketch at Charlestown Landing Sate Park, Charleston, South Carolina. *Photograph by the author.*

Barbados, Lord Willoughby, financed a settlement there in 1650. Since New England merchants were already supplying Barbados with provisions, they decided to supply Surinam. It would not have been out of the question for Hilton to have traded with both Bermuda and Surinam, as other New England ships were trading with those colonies.

He appears to have not only traded with the West Indies and other places but also sold items through a shop attached to his house in Charlestown. His probate inventory taken after his death in 1675 mentioned £41 18s 6d worth "of goods in the shop."[88] Unfortunately, the inventory did not mention what the goods in the shop were, but Hilton might have been selling a variety of imported merchandise. George Corwin, who owned two ketches, also had a shop associated with his residence. His probate inventory taken in 1685 showed that he sold a large variety of items, including fabric, tools, knives, horse tack, cowbells, locks, combs, scissors, pins and needles.[89] Whatever merchandise Hilton was selling, it made up about 25 percent of the total value of the items in his house. Another 25 percent was taken up in money and plate (silver or gold utensils), making that and the goods in the shop worth about half of the £166 value assigned to all his possessions.

By the early 1660s, land in some towns in Massachusetts was beginning to run out. On June 22, 1661, the selectmen of Newbury officially did away

with lot layers, since "there is no more land to be granted by the towne."[90] In 1663, two people in Charlestown petitioned the court

> *on behalfe of the inhabitants of Charls Toune, humbly desiring this Court, on seuerall considerations, to graunt the inhabitants of Charls Toune fiue hundred acres of land in some free place, the sajd inhabitants & toune being streightned by parting wth lands to accomodate Cambridge, Wooborne, & Maulden.*[91]

The need for more space stemmed from the large number of children New England families were having and the fact that most children lived to adulthood. It was not uncommon for families to have seven or more children, which created a population boom within the lifetime of the first generation of settlers. At this time, Hilton had five children by his first wife and would have five more with his second wife.[92]

This desire for more land prompted a group to form the "Comttee for Cape ffair at Boston." The idea was to find a place to start a settlement around the Cape Fear region of what is present-day North Carolina. Cape Fear got its name from the expedition of Sir Richard Grenville to Roanoke Island in 1585. While passing Cape Fear, his ship was in danger of wrecking and his crew became afraid—thus they named it Cape Fear.

Before any settlement could be started, that area would need to be explored and a suitable location for the settlement found. This group enlisted the help of Captain William Hilton and his ship *Adventure*. He was joined on this expedition by his first wife's brother Enoch Greenleaf, his son-in-law Edward Winslow, John Green, James Bate and Samuel Goldsmith. The expedition set sail from Charlestown on August 14, 1662, "for ye discovery of Cape Feare and more South parts of Florida."[93]

At this time, most people called any land south of Virginia, Florida. However, the name Carolina came into use in 1629 when King Charles I granted all land lying approximately between present-day Virginia and Florida to his attorney general Sir Robert Heath. The name Carolina comes from the Latin word for Charles, which is Carolus.

Heath never settled his land, nor were any colonies founded there, and Heath seems to have lost interest in it. Around 1635, he signed over his grant to two young noblemen who also failed to settle the area and also appear to have lost interest. In 1650, a group of men in Virginia explored the northeast area of North Carolina, which they called New Britain. However,

the name that was most associated with what would become North and South Carolina was Florida.

Juan Ponce de León gave Florida its name when he landed there in 1513. He arrived in the spring and was so impressed with the flowers he saw he named this new land la Florida. Eventually, Spain would try to claim everything in North America, and England and France would also try to claim land there as well.

In 1565, the Spanish, after five failed attempts to settle la Florida, finally succeeded in establishing St. Augustine. They now had effective occupation of that area and could lay claim to it. A year later, they would start a settlement on Parris Island called Santa Elena. The Spanish would eventually have missions throughout Florida and along the Georgia coast, including a short-lived mission in Virginia. They even explored into the western part of North Carolina and erected forts there. However, by the middle of the seventeenth century, the Spanish were restricted to their settlement at St. Augustine and a few missions in Georgia and Florida.[94] When Captain Hilton sailed to Cape Fear in 1662, he found no sign of Spanish occupation.

Three weeks after the *Adventure* left Charlestown, it arrived at Cape Fear on September 3. Hilton had a hard time trying to enter what they called the Charles River (Cape Fear River). Contrary winds and storms forced Hilton to put out to sea twice "and fearing our whole voyage would be lost should we make no attempts we laboured through contrary winds and calmes vntill ye 3rd of Oct. before we could arrive in to Cape Fear road."[95]

It took a month after they arrived before Hilton was able to begin exploring the area. The master's mate and some of the crew took out the longboat and began sounding the entrance to the river, noting its depth. They were able to sail the *Adventure* fifteen or sixteen leagues (fifty-two to fifty-five miles) up the river, and then half of them went in the longboat fifteen leagues (fifty-two miles) farther, "till at ye head of the riuer we could not tell which of ye many riuers to take and so returned to our ship."[96]

On their journey, they "found many faire and deep riuers all ye way running in to this Charles riuer which abounds with Sturgeon, and variety of other well tested fish, which some of vs haue eaten off." Oyster beds were also noted at the entrance, but the explorers were not impressed with the beds' size, noting that there were "none so big, as they are in New England." As for the land around the river, they noted that "there are abundance of vast meddows, besides vpland fields, yt render ye Country fit to be calld a Land for Catle." They also discovered some barren land that they thought would be easy to plow and "very good land for several townes; besides for multitudes of farms."

6. A 1781 map by John Lodge and John Bew showing the Cape Fear area Hilton explored in 1662 and 1663. *Courtesy of the Library of Congress.*

As for the forests, there were oaks, cypress, cedar, ash, maple, poplar, willow, pine and bay trees along with "large grape-vines in abundance, and other fruites ye vplands are laden wth," including walnuts. Along with the variety of trees, they noted the abundance of waterfowl and other birds. During their explorations, they did not encounter many Native Americans, "for in all our various travells for 3 weeks and more, we saw not 100 in all, they were very courteous to vs, and affraid of vs."[97]

The expedition concluded its journey on November 6, and they noted that those in New England should not delay in acquiring land in Cape Fear.

> *There is for ye present ground and encouragement enough and more yn enough to make those amongst us, whom it concerned, to purchase and buy ye sd riuer, and ye lands about it, of ye Natiues, it being ye most temperate of ye Tempate Zone, and ye Climat fitted to ye Sole.*[98]

When Hilton and company arrived back in Charlestown, they published their account of the expedition along with a map of the area. On the map, they named rivers and other areas after those who explored the area and for what they found there. For example, there is Hiltons River, Point Winslow, Crane Island and Sachoms Point, named for the sachem of the Native Americans.

In the spring of 1663, a group of New Englanders did try to settle the Cape Fear area, purchasing land from the Native Americans. In order to acquire additional funds for the trip, they sought out people in England "to share in the adventure, and to cast in, at first, a small sum for an assistance or supply to the said undertaking."[99]

The settlers, after acquiring the land, sought a patent for it from the king—apparently, it was never obtained. The cattle they brought with them were placed on the land, but the settlement never flourished. They quickly returned to New England "without so much as sitting down upon it; and for the better justification of themselves in their return, had spread a reproach both upon the harbor and upon the soil of the river itself."[100] Apparently, "they went not into the branch of the river in that Hilton was in, but by mistake went into another besides they tooke not the proper time of the yeare, for worke."[101] This indicates that they did not settle in the correct area and that they possibly went too late in the year to plant crops successfully.

Another possible reason for their departure might have been conflict with the Native Americans in the area. It appears that some were taking Native American children under false pretense and most likely selling them into slavery.

John Lawson, who further explored North and South Carolina, stated in his book published in 1709 that

> had it not been for the irregular Practices of some of that Colony against the Indians, by sending away some of their Children, (as I have been told) under Pretence of instructing 'em in Learning, and the Principles of the Christian Religion; which so disgusted the Indians, that tho' they had then no Guns, yet they never gave over, till they had entirely rid themselves of the English.[102]

However, before these unsuccessful settlers departed, they left a note on a post warning others not to settle there. Captain Hilton and his expedition discovered this note when they visited the area in the fall of 1663:

> Whereas there was a Writing left in a Post, at the Point of Cape-Fair River, by those New-England-Men, that left Cattle with the Indians there, the Contents whereof tended not only to the Disparagement of the Land

about the said River, but also to the great Discouragement of all such as should hereafter come into those Parts to settle.[103]

Around the same time the New Englanders were trying to start their settlement, King Charles II granted to eight Lords Proprietors a large tract of land lying between present-day Virginia and Florida and extending west to the Pacific Ocean for the colony of Carolina. These eight gentlemen all supported the Crown during the English Civil War and were rewarded for their loyalty by this land grant. They were referred to in the charter dated March 24, 1663, as "the true and absolute Lords Proprietors" of Carolina and were described in the charter as

our right trusty, and right well beloved cousins and counsellors, Edward Earl of Clarendon, our high chancellor of England, and George Duke of Albermarle, master of our horse and captain general of all our forces, our right trusty and well beloved William Lord Craven, John Lord Berkley, our right trusty and well beloved counsellor, Anthony Lord Ashley, chancellor of our exchequer, Sir George Carteret, knight and baronet, vice chamberlain of our household, and our trusty and well beloved Sir William Berkley, knight, and Sir John Colleton, knight and baronet.[104]

The king gave these men broad powers in governing the colony of Carolina, and they were to rule "in as ample a manner as any bishop of Durham in our kingdom of England." For many centuries, County Durham was, for the most part, an independent state ruled by prince bishops, not the king. As the steward of Anthony Bek, bishop of Durham from 1283 to 1311, stated:

There are two kings in England, namely the Lord King of England, wearing a crown in sign of his regality and the Lord Bishop of Durham wearing a mitre in place of a crown, in sign of his regality in the diocese of Durham.[105]

By giving the Lords Proprietors the same powers as the bishop of Durham, the king was granting them the power of a king. They could make war or establish peace, maintain an army, impose taxes and duties, create towns, issue pardons or impose a death sentence. In addition to those powers, they were given trading rights with the Native Americans along with fishing rights and the right to any mines or quarries that were discovered. If any commodities proved successful like "silks, wines, currants, raysons, capers, wax, almonds, oyl and olives," they could be imported to England duty-free for seven years.[106]

Of the eight Lords Proprietors, one, Sir John Colleton, was instrumental in trying to colonize Carolina. In England, he served in the army during the English Civil War and supported the monarchy of Charles I. It is said that he spent more than £40,000 of his own money to support the king.[107] He and his family left England after Charles I was executed for treason in 1649 and settled in Barbados. While there, Colleton became a large land owner as well as a planter, merchant, counselor and judge.

With the death of Oliver Cromwell in 1658, Colleton returned to England and joined some of the others who would become Lords Proprietors in returning Charles II to the throne. For his service and loyalty, Colleton was knighted in 1661 and appointed to the Council for Foreign Plantations and the Royal African Company.

When Colleton was in Barbados he no doubt observed the lack of land there. That which was available was too expensive for most people to afford. This led some to leave for other islands in the Caribbean or to immigrate to New England. Colleton knew that if lands were opened up in Carolina, it would benefit both the Barbadians and the Lords Proprietors. There were in Barbados "many hundreds of noble famillyes and well experienced planters that are willing and ready to remove spedily theither to begin a setlement as aforesaid and to beare the brunt thereof."[108] The Barbadians were experienced colonists and could afford to settle in Carolina at their own expense and acquire land at more reasonable rates than in Barbados. The Lords Proprietors in turn had land to sell or rent, which would net them a profit.

In order to find the best place for a settlement, some Barbadians formed a group called the Corporation of the Barbados Adventures. Since the New England colonists had disparaging things to say about the Cape Fear area, the corporation wanted the area south of Cape Fear into present-day South Carolina explored. They decided that the best person to explore this area would be Captain William Hilton. Peter Colleton, John Colleton's oldest son, and Thomas Modyford, a wealthy planter and Speaker of the House of Assembly in Barbados, had "greate confidence in the said Hinton's [sic] fidellity and honest indeavowrs."[109]

On August 10, 1663, Hilton set sail from Speights Bay in Barbados in "his ship Adventure and twenty two men well victualled for 7 months for discovery of that coast southward from Cape Faire as far as 31 degrees north latitude" (near the present-day Georgia-Florida line).[110] He was the commander and commissioner of the expedition and was joined by Captain Anthony Long and Peter Fabian.

4
INDIANS, SPANIARDS AND CASTAWAYS

When Captain Hilton left Barbados, he no doubt had an experienced crew with him. While he was the overall commander of the expedition, Hilton was assisted by Captain Anthony Long, who appears to have been a Barbadian and probably an experienced sea captain as well.[111] While little is known about Peter Fabian, he might have been along to chronicle the expedition. His name, along with that of Hilton and Anthony Long, appear at the end of the published account of the expedition, suggesting all three contributed to writing it.

Out of the rest of the people onboard the *Adventure*, only two are known. They are the ship's masters Pyam Blowers and John Hancock. The masters and their mates were in charge of the day-to-day operation of the ship. This included, upon instruction from the captain, setting and plotting the course of the ship and commanding all the sailors as to the heading and trimming the sails. Although not listed anywhere, there were probably several other people onboard, such as boatswain who would have supervised the deck crew, a carpenter, a cook and the seamen. There probably was a gunner or someone with similar training onboard; during the expedition, a reference was made to "the firing of a Peece of Ordnance," meaning the *Adventure* had some mounted artillery.[112]

After the *Adventure* left Barbados, it only took sixteen days to arrive off the coast of present-day South Carolina. The reason for the *Adventure*'s relatively quick passage was that when it left Barbados, it was able to enter the Gulf Stream—a powerful, warm ocean current that flows north from

Florida before turning east across the Atlantic Ocean off the southern coast of North Carolina. With its combination of winds and currents, the Gulf Stream achieves its fastest speed near the surface and can move at an average speed of around 4.9 knots an hour, which is how the *Adventure* was able to travel a distance of approximately 1,900 miles in sixteen days.[113] Based on how long it took the *Adventure* to arrive off the coast of South Carolina, it was probably averaging about 118.7 miles per day, meaning that it was most likely traveling at a speed of just under 4.3 knots.

The Gulf Stream had been known to Europeans ever since Juan Ponce de León discovered and named Florida in 1513. During his explorations, he noticed this powerful current, which the Spanish would later call the Bahama Channel, flowing north along the east coast of Florida. Throughout the sixteenth century, their treasure ships followed it to ensure a speedy passage back to Spain.

Two centuries before Hilton embarked on his expedition, improvements in navigation enabled Europeans to extend their knowledge of the world in a manner that had not been possible before. Armed with a compass as well as a quadrant, cross staff or astrolabe and using celestial objects such as the North Star or sun as a reference, seafarers were able to measure latitude at sea, which is the distance north or south of the equator. In order to measure longitude, which is the distance east or west, a system based on compass direction, time and speed called dead reckoning was used. Starting at a known point, the navigator measured, to the best of his ability, the direction the ship was heading in, the speed of the ship and how much time was spent on each heading. Based on this information, the navigator could determine the course of the ship and distance covered. Ships were thus able to sail on the wide expanse of the Atlantic, out of sight of land, and have some reasonable expectation of being able to return to their home ports or to find a destination again without difficulty.[114]

Hilton referred to taking "the Meridian-Altitude of the Sun" in order to determine his latitude.[115] He or the ship's masters would have used either a quadrant, cross staff or astrolabe to accomplish this. These handheld instruments were made of wood or brass and were used to determine the angle between the horizon and celestial objects. Using the North Star was best for measuring latitude, as the star was less than one degree from the North Pole, thus making its altitude roughly equal to that of the latitude.

However, clouds could obscure this star, and thus using the sun was often the preferred method for measuring latitude, even though it was a more difficult process. The angle between magnetic north and true north had to

be considered along with the tilt of the earth when measuring the height of the sun. After a reading was taken, the latitude was determined by using a declination table that showed the height of the sun at noon above the equator for every day of the year. Measurements had to be precise, since an error of just one degree could mean being off course by as much as sixty nautical miles.

When using dead reckoning to determine longitude, accurate timekeeping was essential. Most ships used hourglasses or sandglasses. Usually, the sandglasses were four hours in duration, which was how long a shift or watch lasted. Half-hour sandglasses were also used, and usually, a ship's boy would flip one over every thirty minutes and strike a bell for the first half hour and two bells for the next half hour and so on. Thus, when eight bells were heard, it signified that one shift had ended and another had begun.

The sandglass was also used in conjunction with a chip log to determine the speed of the ship. A piece of wood in the shape of a quarter of a circle was attached to a rope that was knotted at regular intervals. The rope was wound up on a spool, and when the log was tossed into the water from the stern of the ship, the knotted line would unwind from the spool and the knots that went by were counted. The number of knots that went by in a given amount of time indicated how fast the ship was going. If three knots came out, then the ship was traveling at a speed of three knots or three nautical miles per hour.

In order to keep track of the course the ship was sailing on during a watch, a traverse board was used. It was a circular piece of wood that depicted the thirty-two points on the compass. Radiating out from each point were eight evenly spaced small holes. When the half-hour bell struck, a peg with a string attached to it and the center of the board was placed into the hole that aligned with the direction the ship was heading. At the next half-hour mark, another peg was inserted and so on.

When a watch was over, a direction was determined from the alignment of the pegs. This information, combined with the recorded speed of the ship, enabled navigators during this period to somewhat accurately determine longitude. All this data was recorded in the ship's log and allowed the navigator to check his dead reckoning. Also, the position of the ship was plotted on charts, which allowed the navigator to see past and present positions.[116]

Using these navigational tools, Hilton's expedition was able to arrive off the coast of present-day South Carolina at four o'clock in the afternoon on August 26. They were fourteen miles "or there abouts to the Northwards

of Saint Ellens,"[117] which was the name the Spanish had given to the area around Port Royal Sound.[118]

The next day, Hilton's expedition began exploring southward, anchoring at night and sending out the longboat in the morning to explore. Finding no good harbor, they turned northward on August 30, and on September 2, they "came to an Anchor in five fathoms [30 feet] at the mouth of a very large opening of three Leagues [10.4 miles] wide, or thereabouts."[119] This "large opening" was St. Helena Sound, and Hilton sent out the longboat to sound the channel.

In order to determine how deep certain areas in the channel were, the sailors used a lead line. It consisted of a lead weight attached to a rope marked by fathoms (one fathom is six feet). The markings were distinctive so

7. Circa 1771 map by Boss, Brailsford and Hodgson showing St. Helena Sound and Port Royal Sound, both of which Hilton explored. *Courtesy of the Library of Congress.*

that one could know the depth by sight or at night by touch. For example, the three-fathom mark was three strips of leather, the five-fathom mark was white calico and the seven-fathom mark was red bunting.

The lead line would be tossed overboard and allowed to sink to the bottom and the depth measured. When out at sea, tallow was often placed on the bottom of the lead weight in order to bring up samples of the bottom. The consistency of the material brought up when compared with charts could help determine a ship's position. In shallow areas, a marked pole could be used instead of the lead line to get depth measurements.[120]

After sounding the channel, they entered the harbor the following day and found what they thought was the Jordan River. It was, however, the Combahee River. Entering the river, they explored its branches and spent time sounding the area inside and outside the harbor.

On September 5, the explorers had their first encounter with Native Americans in the area. Hilton invited two of them to come aboard the ship, where they were "entertained courteously, and afterwards set them on shoar."[121] The following day, more Native Americans came onboard the *Adventure* and said they were from Santa Elena, which was not only the name the Spanish called the entire area but also the name of their failed settlement on Parris Island. The Native Americans were described as

> *being very bold and familiar; speaking many Spanish words, as, Capptian, Commarado, and Adeus* [adios]. *They know the use of Guns, and are as little startled at the firing of a Peece of Ordnance, as he that hath been used to them many years.*[122]

These Native Americans said that the nearest Spanish were at St. Augustine, and several of them had visited there. They reported that it was only a ten-day journey from where they presently were in St. Helena Sound. In addition, they said the Spanish use to visit them at Santa Elena, sometimes arriving in canoes through the inland waterways and sometimes by sea in small ships that they described as having two masts. Hilton and his crew were all invited by the Native Americans to visit them at Santa Elena. However, Hilton was wary and, on September 14, decided to just send twelve men in a longboat for a visit.

While the longboat was gone, five different Native Americans came onboard ship. One of them pointed to another and said he was the "Grandy Captain of Edistow: whereupon we took especial notice of him, and entertained him accordingly, giving him several Beads, and other trade that pleased him well."[123]

Trading for European goods began with the arrival of the Spanish in the Southeast during the sixteenth century. Native Americans quickly realized that these strangers had things of value and seized the opportunity to trade with them. It was through this trade that both sides learned what the other valued most. For the Native Americans, metal tools, glass beads and copper were highly prized. An inventory of items imported to St. Augustine in 1568 for trade with the Native Americans shows a diversity of trade goods. Among the clothing and shoes, the inventory listed

> *6 dozen selected necklaces of crystal and glass, of many types…2 small boxes of brass rings with very pleasing stones…8 new large pruning-knives…A basket with 2 anvils, used adzes, hammers, a sausage-stuffer, 100 saws and other things…50 sewing needles…8 pointed knives with sheaths…5 small mirrors.*[124]

The Spanish were willing to trade these items for animal skins, sassafras roots, oak and cedar, as well as the cochineal bug, which when dried and crushed and added to water exudes a rich, long-lasting red dye that was much sought after in Europe.[125]

When Hilton left Barbados in 1663, he knew exactly what items he needed to bring with him in order to trade with the Native Americans. Besides the beads, Hilton brought with him "Hoes, Hatchets and Bills [a medieval weapon with a hooked blade], etc."[126] The captain of the Edistos, whose name was Shadoo, was apparently pleased with the beads and the other unnamed items he received. Possibly seeking more trade items from the English, Shadoo informed Hilton that he had in his custody five of his fellow countrymen, including someone named Captain Francisco. Hilton showed Shadoo and the other Edistos all the trade items they had, including more beads, along with the hoes and hatchets. Shadoo was informed that if the English were brought onboard the *Adventure* that all the trade items would be his. He agreed and let Hilton know that they would be brought onboard the next day.

Hilton appears to have been leery of the Edistos, for he wrote a few lines in a note to the English captives "fearing it to be a Spanish delusion to entrap us."[127] He had every right to be concerned, since the area he was exploring was considered by the Spanish to be their territory even though they had abandoned the Santa Elena settlement in 1587. But what Hilton was able to gather from the second group of Native Americans to come onboard ship was that the Spanish still visited the area, meaning they might not be overjoyed at the presence of Hilton's expedition. His fears of treachery came to light:

> *In the dark of the same Evening came a Canoa with nine or ten Indians in her with their Bowes and Arrowes, and were close on board before we did discern them: We haled them, but they made us no answer, which increased our jealousie: So we commanded them on board, and disarmed them, detaining two of them prisoners, and sending away the rest to fetch the English; which if they brought, they should have theirs again.*[128]

The Edistos finally brought a note back from the Englishmen on shore, but it was written with a piece of coal, which increased the expedition's suspicions. Also, they had not heard word from the longboat at Santa Elena and thought that their men may have been surprised by the Native Americans and Spanish and either captured or killed.

Meanwhile, in order to show Hilton that there were indeed Englishmen onshore, the Edistos sent one of them to him. The man told Hilton that he and his fellow captives were castaways and had come ashore about four to five leagues (twelve to fifteen miles) north of where they were a couple of months earlier, on July 24. Thirteen of them in all had made it ashore, but three had been killed by the Native Americans.

On September 17, the longboat returned safely from Santa Elena and was sent ashore to fetch the other English captives. Three more were brought onboard, and the two Indian prisoners were released. Shadoo was questioned about the fate of the rest of the English. He related that three were indeed killed by the Stono Indians, five were taken to Santa Elena and the other one would be turned over in two days. Hilton told Shadoo that they would keep him and two of his chief men hostage until all the Englishmen still alive were returned. Once that was done, he told Shadoo that he and his men would be released unharmed and would have "satisfaction for bringing us the English."[129] The three Native Americans kept by Hilton were Shadoo, Alush and another unnamed person.

The Stono, like the Edisto, have been classified as subtribes of a larger group of Native Americans called the Cusabo.[130] Their territory stretched along the coast from Georgia to around what is today Charleston, South Carolina. While Hilton does not describe the physical appearance of the inhabitants he met, a later writer in 1682 did so:

> *The Natives of the country are…of a deep Chestnut Color, their Hair black and streight…their Eyes black and sparkling, little or no Hair in their Chins, well lim'd and featured.*[131]

The population of the different groups at this time is difficult to determine, but a census of the coastal tribes was taken in 1682. At that time, the six tribes in the area had a total of 166 bowmen, with none having more than 50. The Stono had 16, and the Edisto had the lowest number at 10. That number excluded women and children, but if the numbers are multiplied by four to account for them, then the total number of Native Americans was around 664.[132] Diseases, slave raids and wars with the Spanish had taken their toll on the Native Americans in this area, thus having greatly reduced their population by the time Hilton arrived.

While the longboat was at Santa Elena, the crew reported being fearful that the Indians were plotting some treachery. They noticed that they were continually gathering together and that their facial expressions were decidedly stern and unfriendly. The Indians then began to speak to them in rough tones and to search through their pockets and bandoleers (a broad shoulder belt with small pockets or loops for ammunition). However, it appears that once the Native Americans determined that Hilton's men were not an imminent threat, they were invited to spend the night. But the men, probably not feeling entirely welcomed, reported that they "made a sudden retreat to our Boat, which caused the Indian King to be in a great rage, speaking loud and angry to his men; the drift of which discourse we understood not."[133]

The men were at Santa Elena long enough to make some important observations that were reported back to Hilton. What they noted was a

> *fair house builded in the shape of a Dove-house, round, two hundred foot at least, compleatly covered with Palmeta-leaves, the wal-plate being twelve foot high, or thereabouts, and within lodging Rooms and forms; two pillars at the entrance of a high Seat above all the rest: Also another house like a Sentinel-house, floored ten foot high with planks, fastned with Spikes and Nayls, standing upon substantial Posts, with several other small houses round about. Also we saw many planks, to the quantity of three thousand foot or thereabouts, with other Timber squared, and a Cross before the great house. Like wise we saw the Ruines of an old Fort, compassing more than half an acre of land within the Trenches, which we supposed to be Charls's Fort, built, and so called by the French in 1562.*[134]

What Hilton's men saw was evidence that the Spanish were still active in the region. Buildings constructed with nails and spikes along with square timbers and planks as well as a cross were all signs that the Spanish still

had a presence in the area. The ruins of the fort, which they thought was Charlesfort, was actually a Spanish fort. In 1996, archaeologists determined that the Spanish had built one of their forts directly on top of Charlesfort.[135]

On September 21, an English youth named Morgan was brought onboard the *Adventure* from Santa Elena. The Native American who brought him informed Hilton that there were four more being held there and did not know if they would be released or not. It was related that a friar and two more Spaniards were seen at Santa Elena and that the Spanish planned on sending soldiers to take them away.

The next day, three Native Americans came onboard, and Hilton sent a letter with one of them to the English prisoners. It stated:

> *Wee are come up the River with our Ship, and are resolved to come through by Combiheh, to St. Ellens, and to get you away by fair means, or otherways. If that will not do, we have five of your company already: and the Captain of Edi- stow, and one more are Prisoners with us, whom we intend to keep till we have rescued all the English Prisoners out of the hands of the Indians. Send us word by this Bearer what you know concerning the Spanyards; for the youth Morgan tells us that the Spanyards are come with Soldiers to fetch you away. Fail not to inform us how things are. Nothing else at present, but remain*
> *Your friend and Servant Will. Hilton.*[136]

In order to find the best route to Santa Elena, Hilton, on the twenty-third, sent the longboat out to sound the channel to see if they could sail there through the Combahee River. While that was going on, a number of canoes approached the ship carrying "Corn, Pumpions, and Venison, Deer-skins, and a sort of sweet-wood."[137] While looking in the basket of food, one of Hilton's men found a piece of Spanish rusk that appeared to be new. It was demanded of the Indians where the rusk came from, and they replied that it came from the Spanish. A rusk is a dry, hard biscuit that has been baked twice, similar to a ship's biscuit or hardtack. These biscuits were frequently used on ships, as food spoilage was a big problem. Fresh bread, if not eaten right away, would become rancid, but a hard biscuit could last for a year or more.

Meanwhile, four Native Americans arrived from Santa Elena carrying a letter from the Spanish captain there, Alonso Arguelles. When Hilton looked at the letter, he realized that it was written in Spanish and there was no one among his men who could read it. While the English aboard ship were not able to read Spanish, it is possible that someone onboard could speak that

language. Knowing that they were coming to an area where the Spanish had a settlement for twenty years, they likely suspected that they would come across Native Americans who could speak at least some Spanish.

The second group of Native Americans to come onboard ship spoke many Spanish words, and given the amount of information that was exchanged between the two groups, it is likely that they were able to understand each other in a meaningful way. When Hilton was in the Cape Fear area, he noted that the Indians "made us understand by signes" what they were communicating.[138] However, when he was in the Port Royal Sound area, no reference was made to using sign language.

Hilton was told by the Indians that there were now seven Spanish and one Englishman at Santa Elena. At this point, Hilton decided to keep two of the four Native Americans who brought the note as captives, bringing the total number of captives he had to five. One of them was Wommony, who was the son of the chief at Santa Elena. They were told that when the English prisoners were returned, they would be set free "with satisfaction for their pains," meaning that they were probably going to give them more trade goods. The other two Indians were sent off with a letter to the Spanish captain in which Hilton related that they did not understand his letter and that they did not have any business with the Spanish, just with the Native Americans for the releases of their fellow countrymen:

> *Whereas wee received a Letter from you, the Contents whereof we understand not, because none of us could read Spanish: Our businesse is to demand and receive the English Prisoners from the hands of the Indians, and then they shall have their Indians which we have detained on Board, with satisfaction for their pains. We understand not at present that we have any businesse with you. Not else at present, but remain Your Friend and Servant in what I may,*
> *Will. Hilton.*[139]

The next day, an Indian brought another letter from Captain Arguelles; it also contained a response to Hilton's first letter to the English captives. In addition to the letter, Captain Arguelles sent a quarter of venison and pork with his compliments and said that he was sorry he had no more to give. Hilton in return sent a jug of brandy with his thanks and an apology for not being able to understand his second letter. He also wrote a few lines to William Davis, who was one of the English prisoners:

> *Wee received your Lines in the Spanish Letter, but hear nothing of your coming to us. Let your Keepers send you, and that without delay; for you may assure them, That we will be gone, and carry the Indians away with us, except they send the English suddenly on Board, and then they shall have their Indians upon our receipt of the English. Not else at present, but thank the Spanish Captain for the Pork and Venison he sent us. Remain*
> *Your loving Friend*
> *Will. Hilton.*[140]

Unknown to Hilton at the time was the content of Captain Arguelles's letters, which were later translated into English and included in the published account of the expedition. Both letters contain almost the exact same information and inform Hilton:

> *My Governour and Capt. General, as soon as he had News that a Ship, by Nation English, was lost in that Port in which you now are, sent me with Soldiers of the Garison of St. Augustine in Florida, as they have at other times done, to free them from death; for which cause I came to this Port of St. Ellens, where I found all these Indians in a fright, fearing that you will do them some mischief: So having found four men of those that were lost, I thought good to advise you, that you might carry them in your company, giving some gifts to those Indians which they desire; which is, four Spades, four Axes, some Knives, and some Beads. This they desire, not as payment, but onely as an acknowledgment of a kindness for having saved their lives; which they have always done as Naturals who have given their obedience to the King our Master. And they do also desire you to let go those four Indians which are there: You may send a Boat when you discover the Points of St. Ellens; may hoist an Ancient [Flag] two or three times, and I will do the same. I desire your Answer may be sodain; for I am scarce of Provisions, and the way is somewhat long: and if you have no body who understands Spanish, you may write in English, for here are your Countrey-men who will interpret it.*[141]

It seems that Captain Arguelles was advising Hilton on what to do in order to secure the release of the English prisoners, and his advice appears to be exactly what Hilton had in mind. He wanted to exchange the Native Americans he held for the English captives and give the Indians "satisfaction for their pain" in the form of more trade goods.

Everything seemed set for an exchange of prisoners, but on September 25, Hilton decided to return down the Combahee River, fearing that the Native Americans would attack. He observed them gathering themselves en masse, and as his ship moved down the river, so did they. He had also been informed by one of the Native Americans that Spanish soldiers would arrive at Santa Elena the next day and no doubt wanted to position his ship to be able to quickly sail into Port Royal Sound. That night, one of the Native American prisoners escaped by jumping overboard and swimming away.

The *Adventure* sailed down to the harbor's mouth on the twenty-sixth and stayed there for two days. In that time, nobody came to them. Determining that the intensions of the Native Americans were not good, Hilton decided to put out to sea and plot a course for Port Royal Sound.

When Hilton entered Port Royal Sound, he was entering one of the largest natural deep-water harbors on the southeastern coast. After arriving in the sound, he had the depth of the channel measured out toward the ocean since the inner portion had already been measured when the longboat was sent to Santa Elena. What followed was a detailed description about how to navigate the sound. They found that

> *the N.E. and E.N.E. side of the opening of Port-Royal to be Sholes and Breakers to the middle of the opening; and three leagues* [10.4 miles] *or thereabouts into the Sea, from the side aforesaid, is unsafe to meddle with.*[142]

However, they found the southwestern and west side of the sound to be "bold steering" and that if a ship were to sail into the sound, it should head north–northwest and stay two or three miles from the sholes and breakers. Hilton also stated that one needed to sail "directly with the S.W. head-land of the entrance of Port-Royal: the said head-land is bluft, and seems steep, as though the trees hung over the water."[143] That headland Hilton named Hiltons Head.

When describing the areas they explored, Hilton and his fellow coauthors had nothing but exceptionally glowing things to say:

> *The Lands are laden with large tall Oaks, Walnut and Bayes, except facing on the Sea, it is most Pines tall and good: The Land generally, except where the Pines grow, is a good Soyl, covered with black Mold, in some places a foot, in some places half a foot, and in other places lesse, with Clay underneath mixed with Sand; and we think may produce any thing as well as most part of the Indies that we have seen. The Indians plant in the worst*

Land, because they cannot cut down the Timber in the best, and yet have plenty of Corn, Pumpions, Water-Mellons, Musk-mellons.[144]

They go on to describe the countless number of waterfowl they observed, the names of most of which they did not know. Also, they noted that the land "abounds with Grapes, large Figs, and Peaches; the Woods with Deer, Conies, Turkeys, Quails, Curlues, Plovers, Teile, Herons."[145] As for fish, they saw plenty of them and noted how they saw them "play and leap."[146] There was an abundance of oysters, mussels and clams, which they called "horse feet."

The land they thought was very healthy since most of the Native Americans they saw were fit, and they also saw many who were old. They also thought it was healthy because

the English that were cast away on that Coast in July last, were there most part of that time of year that is sickly in Virginia; and notwithstanding hard usage, and lying on the ground naked, yet had their perfect healths all the time.[147]

8. A 1732 map by Herman Moll showing Port Royal Sound. *Courtesy of the Norman B. Leventhal Map & Education Center at the Boston Public Library.*

In the early seventeenth century, Virginia developed a reputation as being an unhealthy place to live, particularly in the summer. Diseases such as typhoid fever and dysentery would plague Jamestown practically every summer, killing about 30 percent or more of the population. Jamestown is located on the James River, which is a tidal river. In the spring, melting snows in the mountains to the northwest brought large amounts of fresh water to the river as it swept past Jamestown on its way to the Chesapeake Bay. However, during the rest of the year, salt-water tides swept past Jamestown Island, making the water brackish. This brackish water contaminated the settlers' water supply on the island, making anyone who drank it sick. In 1624, when Virginia became a royal colony, people began moving away from Jamestown and settling on widely scattered tobacco plantations with good sources of fresh water, and their health improved. Despite the fact that conditions in Virginia were much better by the time Hilton embarked on his expedition, the perception of Virginia as being a sickly place in the summer still persisted.[148]

In summary, Hilton's expedition thought that in the areas they explored,

> *The Ayr is clear and sweet, the Countrey very pleasant and delightful: And we could wish, that all they that want a happy settlement, of our English Nation, were well transported thither, etc.*[149]

On September 29, Hilton left Port Royal Sound and headed north to explore along the coastline. He went to just south of Winyah Bay, noting that after he passed what would become Charleston Harbor that there were no good entrances for his ship. When he was near Winyah Bay on October 3, "a violent storm came up," and the "windes and fowl weather continued till Monday the 12th."[150] When the storm arose, Hilton put out to sea to ride it out. By the time things had calmed down, the storm had pushed them almost up to Cape Hatteras in present-day North Carolina.

The *Adventure* came to anchor at Cape Fear on the twelfth, with bad weather continuing until the fifteenth. On the sixteenth, Hilton weighed anchor and sailed up the Cape Fear River; some Native Americans came onboard "and brought us great store of Fresh-fish, large Mullets, young Bass, Shads, and several other sorts of very good well-tasted Fish."[151]

Hilton sailed down to the cape the next day to see the cattle left by the New Englanders who had tried to start a settlement there the previous year. After looking for the cattle in vain, he and his men explored the area on land since they could not sail up the river due to contrary winds. It

was not until the twenty-fourth that they were able to enter the river and continue their explorations.

They sailed up the river as far as they could go and even towed the *Adventure* to get it farther along. The longboat was sent out to go into areas that the *Adventure* could not sail into, and after exploring some of the branches of the river, the crew with the longboat returned to the ship. On November 16, they went back down the river to a place they called "turkey quarter" because they killed several turkeys there. They viewed the land in that area and found

> *some tracts of good Land, and high, facing upon the River about one mile inward, but backwards some two miles all Pine-land, but good pasture-ground: we returned to our Boat, and proceeded down some two or three leagues* [6.9–10.3 miles], *where we had formerly viewed, and found it a tract of as good Land as any we have seen, with as good Timber on it.*[152]

On November 17, they were at the mouth of Green's River and fitted the ship to put out to sea again and proceeded down the river. Three days later, they were at the mouth of Hilton's River and on the twenty-third decided to send the longboat, well provisioned and manned, to explore the river. It was during this trip up Hilton's River that the crew of the longboat was shot at by a Native American. Four Indians in a canoe approached them and sold them several baskets of acorns and left. However, one of them followed the longboat on shore and "shot an Arrow at us, which missed one of our men very narrowly, and stuck in the upper edge of the Boat, which broke in pieces, leaving the head behind."[153] The crew went onshore and tried to find the culprit but could not locate him:

> *At last we heard some sing further in the Woods, which we thought had been as a Chalenge to us to come and fight them. We went towards them with all speed, but before we came in sight of them, we heard two Guns go off from our Boat, whereupon we retreated with all speed to secure our Boat and Men: when we came to them, we found all well, and demanded the reason of their firing the Guns: they told us that an Indian came creeping on the Bank as they thought to shoot at them, therefore shot at him a great distance with Swan-shot, but thought they did him no hurt, for they saw him run away.*[154]

While the crew was talking at the longboat, two Native Americans approached

> *with their Bows and Arrows, crying Bonny, Bonny: we took their Bows and Arrows from them, and gave them Beads, to their content. Then we led them by the hand to the Boat, and shewed them the Arrow-head sticking in her side, and related to them the businesse; which when they understood, both of them manifested much sorrow, and made us understand by signes, that they knew nothing of it: so we let them go.*[155]

The men continued down the river until they came across the canoe of the Indian who had taken a shot at them. After destroying the canoe, they approached a group of Native Americans, who immediately ran away. Among the several huts they found what they thought to be the hut of the Indian who shot at them. They "pulled it down, brake his pots, platters, and spoons, tore his Deer skins and mats in pieces, and took away a basket of Akorns."[156] As they made their way farther down the river, they saw someone peering over an embankment.

> *we held up a Gun at him; and calling to him, said, Skerry: presently several Indians appeared to us, making great signes of friendship, saying, Bonny, Bonny, and running before us, endeavouring to perswade us to come on shoar; but we answered them with stern countenances, and said, Skerry, taking up our guns, and threatening to shoot at them; but they cryed still Bonny, Bonny: And when they saw they could not prevail, nor perswade us to come on shoar, two of them came off to us in a Canoa, one padling with a great Cane, the other with his hand; they came to us, and laid hold of our Boat, sweating and blowing, and told us it was Bonny on shoar, and at last perswaded us to go ashoar with them.*[157]

When the Englishmen came onshore, they were greeted by nearly forty men. They showed them the arrowhead stuck in the boat and a piece of the canoe they destroyed. At this point,

> *the chief man of them made a large Speech, and threw Beads into our Boat, which is a signe of great love and friendship; and made us to understand, when he heard of the Affront which we had received, it caused him to cry: and now he and his men were come to make peace with us, making signes to us that they would tye his Arms, and cut off his head that had done us that abuse.*[158]

Apparently as a good-will gesture, the crew were presented with "two very handsom proper young Indian women, the tallest that we have seen in this Countrey."[159] They thought these women were important and suspected that one was the chief's daughter. The women were not taken by the crew, but they gave the chief a hatchet and some beads and also some beads to the women and the rest of the Indians there.

On December 1, the expedition purchased the river and land around Cape Fear from "Wattcoosa, and such other Indians as appeared to us to be the chief of those parts."[160] Before they left, they came across a note on a post at the Point of the Cape Fear River left by the New Englanders who had tried to settle the area the previous year. Hilton did not reveal what the note said but only that it "tended not only to the disparagement of the Land about the said River, but also to the great discouragement of all those that should hereafter come into those parts to settle."[161] He and his fellow coauthors responded "to that scandalous writing" by stating,

> *That we have seen facing on both sides of the River, and branches of Cape-Fair aforesaid, as good Land, and as well Timbered, as any we have seen in any other part of the world, sufficient to accommodate thousands of our English Nation, lying commodiously by the said River.*[162]

With the wind being fair, the *Adventure* weighed anchor and set sail for Barbados on December 4, 1663, arriving in Bridgetown on January 6, 1664. The crew left with at least five out of the ten surviving castaways and four Native American captives: Shadoo, Wommony, Alush and another unnamed person. Hilton does not relate whether or not the one castaway from the first group that was supposed to be brought onboard within two days was ever turned over. The fate of the other castaways is unknown, but it is likely that they were turned over by the Native Americans to the Spanish. After surviving "several known apparent dangers both by Sea and Land," Hilton's expedition was safely back, and William Hilton, Peter Fabian and Anthony Long went to work "to render an Accompt of our Discovery."[163]

5
SETTLING THE CAROLINAS

When Hilton and the others went about compiling their account of the expedition, the one thing they had to keep in mind was that whatever they wrote would have to be approved by the government. In 1662, "An Act for preventing the frequent Abuses in printing seditious treasonable and unlicensed Books and Pamphlets and for regulating of Printing and Printing Presses" was passed. It was thought necessary since

> *by the general licentiousnes of the late times many evil disposed persons have been encouraged to print and sell heretical schismatical blasphemous seditious and treasonable Bookes Pamphlets and Papers.*[164]

The act stated, in part, that no

> *Doctrine or Opinion shall be asserted or maintained which is contrary to Christian Faith or the Doctrine or Discipline of the Church of England or which shall or may tend or be to the scandall of Religion or the Church or the Government or Governors of the Church State or Common wealth or of any Corporation or particular person or persons whatsoever nor shall import publish sell or dispose any such Booke or Books or Pamphlets nor shall cause or procure any such to be published or put to sale or to be bound stitched or sowed togeather.*[165]

Anyone wishing to publish something would have to register with the Company of Stationers of London or be a member of the company. Also, the act limited the number of printing presses in London to just twenty. Anyone found to be printing, selling or distributing any material not authorized by the government could for the first offence,

> be disenabled from exercising his respective Trade for the space of three yeares and for the second offence shall for ever thence after be disabled to use or exercise the Art or Mystery of Printing or of Founding Letters for Printing and shall alsoe have and receive such further punishment by Fine Imprisonment or other Corporal Punishment not extending to Life or Limb.[166]

The person who was charged with enforcing this new law was Roger L'Estrange. As the licenser of books and surveyor of the press, his job was to stop the publication of seditious writings. He also had the authority to have the shops of booksellers and printers searched for unauthorized material. Richard Moon, who was a bookseller in Bristol, had his shop searched in one of L'Estrange's raids. The city militia was sent to his place of business in 1663 to search for seditious material. They found two seditious books, which were burned, and found some suspicious letters as well.[167]

Moon was imprisoned but was released by 1664; that year, he printed *A Relation of a Discovery Lately Made on the Coast of Florida* by William Hilton, Anthony Long and Peter Fabian and was selling it in his bookshop. He apparently had dealings with Simon Miller, a bookseller in London, who had also printed Hilton's book and was offering it for sale in his shop in St. Paul's churchyard. At this time, St. Paul's churchyard was the center of the book trade for the entire country.[168]

On the second page of *A Relation of a Discovery Lately Made on the Coast of Florida* are the words "Licensed June 22. 1664. Roger L'Estrange."[169] This meant that the publication was licensed by the government and contained no seditious or otherwise disparaging material toward the government or church. Since this document was intended to be used as propaganda to entice colonists to come to Carolina, there was no need for it to offer any political opinion or be divisive in any way.

Included in the book was a proposal by the commissioners of the Lords Proprietors

> to all such Persons as shall undertake to become the first Setters on Rivers, Harbours, or Creeks, whose Mouth or Entrance is Southwards or

> *Westwards of Cape St. Romana in the Province of Carolina, and execute the same at their own hazard and charge of Transportation, Ammunition, and Provisions, as is hereafter expressed, etc.*[170]

There were eighteen parts to the proposal, and the first three dealt with land grants to Hilton and all those aboard the *Adventure*:

> *That in consideration of the good service which Captain Anthony Long, Captain William Hilton, and Mr. Peter Fabian have done in making so clear a Discovery on that Coast, They shall each of them enjoy to them and their Heirs forever one thousand Acres of Land apiece upon the said River, Harbour, or Creeks, on such places as they shall desire, not taken up before.*[171]

Ship masters Pyam Blowers and John Hancock were each granted five hundred acres, while the rest of the seamen were granted one hundred acres each. Also, anyone who had invested in Hilton's voyage would receive five hundred acres of land for every one thousand pounds of sugar they had contributed with the provision that within five years they would

> *have one Person white or black, young or old, transported at their Charge as aforesaid, on that or some other parcel of Land in the Province, for every hundred of Acres of Land that is or shall be due to them for their adventures as aforesaid: But when once taken up, to settle the same within one year after it is once taken up, or lose the Land.*[172]

In order to encourage people to be one of the first group to settle the area, a reward system was devised. Settlers who came at their own cost with the first fleet and brought a musket, ten pounds of powder, twenty pounds of bullets or lead and food for six months were granted one hundred acres of land plus an additional one hundred acres for every male servant they transported who was provided with the same arms and provisions. Those who arrived with the second wave of settlers were to get seventy acres, those that came within two years were granted fifty acres and if they arrived within five years they received forty acres.

Indentured servants would also receive land after their servitude was over based upon when they arrived. Male servants who arrived with the first wave of settlers were to get fifty acres, those who came second thirty acres and those who arrived within five years were entitled to twenty acres. Women

servants were granted ten acres each. Settlers who owned slaves would also receive land for those they brought with them or had transported:

> *To the Owner of every Negro-Man or Slave, brought thither to settle within the first year, twenty acres; and for every Woman-Negro or Slave, ten acres of Land; and all Men-Negro's, or slaves after that time, and within the first five years, ten acres, and for every Woman-Negro or slave, five acres.*[173]

All land owners would be allowed to choose representatives to form an assembly in order to pass laws. This assembly, along with the governor, would oversee the colony contingent upon approval by the Lords Proprietors. There would also be freedom of trade and freedom from custom duties on items imported to England for seven years. The land would be taxed at a rate of one-half penny for every one hundred acres, to be paid to the Lords Proprietors or their agents.

In 1664, John Vassall and others from Barbados tried to colonize the Cape Fear area. Some of these men had helped to finance Hilton's expedition and were now interested in starting a settlement in that area, as Hilton had already acquired land there from the Native Americans. The Corporation of Barbados Adventurers was formed, and Thomas Modyford and Peter Colleton, two of its members, were supposed to negotiate the conditions for colonization with the Lords Proprietors. Apparently, John and his cousin Henry Vassall did not want to go through the corporation but instead wanted to deal directly with the Lords Proprietors themselves.

With two seemingly conflicting groups trying to negotiate the terms for settlement, the Lords Proprietors decided to deal with the Corporation of Barbados Adventurers represented by Modyford and Colleton. In response, a separate group was formed called the "Adventurers and planters of Cape Feare," and Henry Vassall was selected to go to London and negotiate terms for settlement. While the terms were somewhat different than those that had already been proposed, they were accepted. However, before the terms could be finalized, John Vassall set sail for Cape Fear and landed there on May 29, 1664, founding a settlement he named Charles Towne. By the end of the year, Charles Towne had become part of Clarendon County and John Vassall was appointed deputy governor and surveyor-general. Unfortunately, the terms of colonization were never finalized with the Lords Proprietors, and another group of Barbadians lead by John Yeamans proposed a settlement at Port Royal, which was an area the Lords Proprietors were very interested in having settled.

9. A 1666 facsimile map by George Schroeter showing the 1664 Charlestown settlement in the Cape Fear, North Carolina area. *Courtesy of the UNC University Libraries.*

In order to entice settlers to come, more inducements were added to make immigrating to Carolina more attractive. Besides the promise of land and freedom from custom duties on certain commodities for seven years, those who settled in Carolina would have "full and free Liberty of Conscience granted to all, so that no man is to be molested or called in question for matters of Religious Concern."[174] Also, the governor would only be in office for three years and could not tax the people or change the laws without consent from the assembly.

There was also a plea to younger sons "of Gentile blood" to come to Carolina.[175] Since the oldest son usually inherited his father's estate, younger sons generally were left with little or nothing. Sir William Berkeley, who was one of the Lords Proprietors and governor of Virginia, stated that

> *a small sum of money will enable a younger brother to erect a flourishing family in a new world; and add more strength, wealth and honor to his native country, than thousands did before.*[176]

Before John Yeamans set out for Carolina, the Lords Proprietors persuaded King Charles II to make him a knight baronet, which was done in January 1665. He was also made "Governor of our County of Clarendon neare Cape Faire and of all that tract of ground which lyeth southerly as farr as the river St. Mathias [St. Johns River, Jacksonville, Florida] and west as far as the South Seas [Pacific Ocean]."[177] The Lords Proprietors wanted the settlement at Port Royal to be a distinct government from that at Cape Fear in the County of Clarendon. Therefore, it would be called the County of Craven.

Sir John Yeamans was the younger son of John Yeamans, a brewer, and was born in Bristol, England, in 1611. During the English Civil War, he became a colonel and fought for the Royalists. After Charles I was executed, he, like many other Royalists, moved to Barbados in 1650. There he became a judge, a member of the council and a large landowner. His wife died in the late 1650s and he then seems to have been involved with Margaret Berringer, who was the wife of his business partner and neighbor, Benjamin Berringer. In January 1661, Benjamin and Margaret appear to have had an argument, prompting Benjamin to leave and go to Speightstown. It was alleged that Yeamans had him poisoned, for he died there at a friend's house. Yeamans married Margaret just a few months later in April and was cleared of any wrongdoing in the death of her husband.[178]

Yeamans sailed from Barbados with three ships in October 1665 and headed for Cape Fear. From there, he was planning to head down to Port Royal Sound to found a colony at that location. As Hilton noted, trying to sail into the Cape Fear River can be very tricky, which Yeamans found out when he tried to enter it. While attempting to maneuver the largest of the three ships, which was 150 tons, into the river, the captain ran it aground. According to the report, the ship struck "on the Middle ground of the harbours mouth, to the Westward of the Channell," causing it to take on water and sink.

All the people onboard escaped unharmed, but the supplies the ship was carrying were lost, including the military provisions that were to be used to protect the colony. One of the other ships, which was supposed to be used to explore Port Royal Sound, was dispatched to Virginia to get additional supplies, but apparently, it was not in good shape. It was described as "being ready by reason of her extreme rottennes in her timbers to sink." As luck would have it, on the ship's return to Cape Fear with supplies, it was driven onshore during a storm. Two men died, and the supplies onboard were lost.[179]

Yeamans did not stay in the colony for long. He left at the end of December and returned to Barbados. Plans were made, however, before he

left to have the secretary of the colony, Robert Sandford, explore the Port Royal Sound area in order to find a suitable place for a settlement. Yeomans never returned, and the colony, which at one point numbered around eight hundred people, was abandoned for good in the summer of 1667.[180]

The colony at Cape Fear might have survived if it had received adequate support from home. However, events taking place in the rest of the world diverted attention from the settlement, leading to its neglect. First was the outbreak of war with the Dutch in 1665; the conflict lasted for two years. This was the second of three wars with Holland during the seventeenth century and was prompted by attacks from the English on Dutch slave trading bases in West Africa in 1663 and the capture of New Amsterdam (New York) in 1664. In 1665, the Dutch recaptured their trading bases in West Africa and also attacked Barbados in April of that year.[181]

While the war was ongoing, in 1665, an outbreak of bubonic plague began in London and caused not only numerous deaths but also the disruption of the government. It has been estimated from city records that around 68,596 people died in London as a result of the plague, but the actual number might have been over 100,000, about one quarter of the population of London. During the outbreak, King Charles II and his court left London for about nine months, and Parliament only met in short sessions in Oxford.[182]

If that were not enough, on September 2, 1666, a fire broke out in a bakery on Pudding Lane near London Bridge. The fire spread quickly, and three hundred houses were soon consumed by the flames. The wind spread the fire, and efforts to quell it with buckets of water were to no avail. In a desperate measure, houses in the path of the fire were destroyed in hopes of keeping the fire from spreading. After it was over, only one fifth of London was intact, and hundreds of thousands of people were left homeless.[183]

During this turbulent time, Robert Sandford was able to undertake his expedition to Port Royal Sound as instructed by Yeomans before he left. Since the ship he was supposed to use was wrecked returning from Virginia, he was directed by Yeomans to hire Captain Edward Stanyarne's vessel. However, when Captain Stanyarne was sailing back to Cape Fear from Barbados he "lost his reason, and after many wild extravagancyes leapt overboard in a frenzye."[184] Stanyarne drowned, and the rest of the crew was able to get the ship safely to Cape Fear. When the ship arrived, Sandford now had a vessel to undertake his expedition but no experienced captain to sail it. He recruited a few people in the colony who had some sailing experience but

> *none here skilled in Navigation to be persuaded to the Voyage, least therefore a worke soe necessary to promote the settlement of this Province should be poorely left without an attempt, Myselfe undertooke the Office, though noe better capacitated for it then a little reading in the Mathematicks had rendred mee with the helpe of a fewe observations made whilst a passenger in some late Sea Voyages to divert their tedium.*[185]

When he prepared to leave, he had eighteen people with him, including three of the original crew's company, two men and a boy. He also took a smaller ship manned by three people that would be able to explore farther into the rivers than the larger ship. With a few experienced sailors and Sandford taking on the role of navigator, they started their expedition on June 14, 1666.

On June 22, they entered a river that was probably the North Edisto River and were greeted by some Native Americans who said that this was the country of Edisto. One of the Native Americans there was someone who used to come up to the Cape Fear area and trade. He said that he was from the country of Kiawah and very much wanted Sandford's expedition to go there. Sandford told him that first they needed to go to Port Royal but would then see his country on the way back. The Kiawah native decided to stay onboard and accompany Sandford to Port Royal.

The next day, Sandford went up a creek and "landed and, according to my instructions, in presence of my Company took a formall possession by turffe and twigg of that whole Country."[186] Returning to the ship, Sandford and his company were greeted by the captain of the Edisto, Shadoo, whom Sandford related was in Barbados with Captain Hilton.

It seems that Shadoo and the rest of the Native Americans taken by Hilton were safely returned to their homeland. No mention is made of how or when this took place, but it is likely that Hilton dropped them off on his way back to New England. Considering the need for labor in Barbados, Hilton could have easily sold them into slavery like so many other Native Americans had been and turned a nice profit. Perhaps realizing the Lords Proprietors were anxious for a settlement in the Port Royal Sound area, he might have decided to keep up good relations with the Native Americans in that area and return them.

Shadoo was apparently anxious for Sandford and his men to come to his village, which was a short distance away, and spend the night. Four men volunteered to go with Shadoo, and since some of the Native Americans had already made it a point to sleep aboard ship, Sandford gave his approval.

Captain William Hilton and the Founding of Hilton Head Island

They returned

> the next morning with great Comendations of their entertainment, but especially of the goodnesse of the land they marcht through and the delightfull situation of the Towne.[187]

This aroused Sandford's curiosity, so he decided to see the village for himself. He took some of his men with him and

> marched thitherward followed by a long traine of Indians, of whome some or other always presented himselfe to carry mee on his shoulders over any the branches of Creekes or plashy corners of Marshes in our Way.[188]

When they arrived in the village, Sandford took in everything he saw, including the fields of corn, the houses and a game they played, which appeared to have been chunkey. That game is normally a two-person game, and spectators would often bet on the outcome. A disc-shaped stone was rolled along the ground, and large sticks or spears (Sandford relates the sticks were six feet long) were thrown with the goal of either hitting the stone or having one's stick end up as close to the stone as possible when it stopped rolling. He also described the reception they received when they entered the village:

> Being entered the Towne wee were conducted into a large house of a Circular forme (their generall house of State). Right against the entrance way a high seate of sufficient breadth for half a dozen persons on which sate the Cassique himselfe (vouch safing mee that favour) with his wife on his right hand (shee who had received those whome I had sent the evening before). Hee was an old man of a large stature and bone. Round the house from each side the throne quite to the Entrance were lower benches filled with the whole rabble of men, Women and children. In the center of this house is kept a constant fire mounted on a great heape of Ashes and surrounded with little lowe furrows. Capt. Cary and my selfe were placed on the higher seate on each side the Cassique, and presented with skinns, accompanied with their Ceremonyes of Welcome and friendshipp (by streaking our shoulders with their palmes and sucking in theire breath the whilst).[189]

Sandford and his men stayed in the village for a few hours and then returned to the ship. Their next stop was Port Royal Sound. He was able to successfully enter the sound, and when he entered it he observed a headland

called from the first discoverer Hilton Head, which is the farthest land in sight as you come from the North East along by the end of Cary Island, whence it beares neerest S.W. and is bluffe, with trees large and tall, which as you approach them seeme to looke their topps in the Sea.[190]

They anchored off of present-day Parris Island near the village that Hilton's men had previously visited. They spent a few hours there, noting the similar layout of that village to the first one they had seen and also noticed a large wooden cross that had been erected there by the Spanish. The area around Port Royal Sound they thought was much better than the area they had previously visited:

It was noe smale rejoyceing to my Company (who began to feare that after Edistowe they should see nothing equally to content them) to finde here not only a River so much superiour to all others on the Coast Northward, but alsoe a Country which their fancyes though preengaged could scarce forbeare to preferre.[191]

When they were done at the village, they returned to their ship and there meet up with the smaller ship that accompanied them. Ensign Baryne, who was in charge of the smaller ship, tried to meet up with Sandford earlier but was in the wrong area. Figuring that Port Royal Sound was farther south, he made his way there. On his journey, he met Wommony, who also was in Barbados with Hilton. Wommony came onboard and guided him through the different creeks and branches that led to Port Royal Sound.

Both Shadoo and Wommony apparently did not have any problems coming onboard the English ships and helping Sandford's expedition. Considering that Hilton held them against their wills and took them to Barbados, it would be understandable if they were leery of these newcomers. But that was not the case, and Hilton, it appears, treated them well enough that there were no hard feelings.

When Ensign Baryne was traveling down to Port Royal Sound he had the

oportunity of veiwing all that part of the Country, which hee did soe loudly applaud for land and rivers that my Companies Comendacons of Eddistowe could scarce out noise him.[192]

Even though Sandford and his men thought highly of the area around the North Edisto River, Port Royal Sound was even better. This confirmed what Hilton had thought about the area and why both the French and Spanish had tried to settle there. Since this area appeared to be superior, Sandford decided to explore it more and went up the Broad River. When he returned, he decided to explore a river on the west side of the sound, most likely Skull Creek, which runs between Hilton Head Island and Pinckney Island. They were told by the Native Americans that this creek led to a large river to the south that went far inland—probably the Savannah River. When they explored Calibogue Sound, they

> *went a shoare on Severall Islands, found them as good firme land as any wee had seene, exceedingly timbred principally with live Oake and large Cedar and Bay trees then any I had seene before on all the Coast.*[193]

Sandford and his men were impressed with this area and thought

> *that of what we sawe in this Sound onely might be found habitations for thousands of people with conveniencyes for their stock of all kinds in such a way of accomodacon as is not comon. And if the Sound goe through to such a great River as the Indians talk off (which seems very probable) it will putt in addiconall value upon the Settlemto that shal be made in it.*[194]

On July 7, the expedition made plans to return to Cape Fear, but the explorers were interested in seeing Kiawah—they still had one of the Native Americans from that region onboard. Right before nightfall, the chief of Native Americans in Port Royal brought onboard his sister's son. The chief inquired about how many moons would pass before he would be returned, hoping that it would be no more than three. Sandford related that it would be ten months before he would be back. Despite being longer than requested, the chief's nephew went with Sandford. In exchange Sandford left

> *an English man in their roome for the mutuall learning their language, and to that purpose one of my Company Mr. Henry Woodward, a Chirurgeon [surgeon], had before I sett out assured mee his resolucon to stay with the Indians if I should thinke convenient.*[195]

Having delivered Woodward to the village on Parris Island, Sandford gave "Woodward formall possession of the whole Country to hold as Tennant att

Will of the right Honoble the Lords Proprietors."[196] The expedition sailed the next day and arrived at Kiawah on the tenth. The ship entered what would become Charleston Harbor and came to a river that Sandford named the River Ashley after one of the Lords Proprietors, Anthony Ashley Cooper. On July 12, the expedition arrived at Cape Fear and had recollections of their journey published later that year.

Meanwhile, Henry Woodward was learning the language and customs of the Native Americans, but unfortunately for him, in 1667 the Spanish discovered his presence and he was captured and imprisoned at St. Augustine. A year later, he was rescued when an English privateer named Robert Searle raided St. Augustine. He became a surgeon on Searle's ship and ended up being stranded on the island of Nevis in 1669 when the ship he was on wrecked during a hurricane.[197]

About the time Woodward became stranded, the Lords Proprietors, spurred on by Anthony Ashley Cooper, once again became active in promoting a settlement in Carolina. Cooper, along with the other Lords Proprietors and John Locke, who was secretary to the proprietorship, wrote the Fundamental Constitutions for the Carolina colony and started making arrangements for an expedition. Locke, who at this time was living in Lord Ashley's household, was one of the most renowned philosophers and political theorists of the seventeenth century. He is also considered the founder of a school of thought known as British Empiricism, which stressed that knowledge was gained mainly through sensory perception and/or experience.[198]

The Fundamental Constitutions of Carolina, which are sometimes referred to as the "Grand Model," contain 120 articles outlining the form of government in the new colony and replaced the previous Concessions and Agreements from 1665. This new constitution limited the role of self-government, as the Lords Proprietors wanted to "avoid erecting a numerous democracy."[199] The one thing that the constitution did was to continue the idea of religious freedom. Article 97 stated in part that

> *since the natives of that place, who will be concerned in our plantation, are utterly strangers to Christianity, whose idolatry, ignorance, or mistake gives us no right to expel or use them ill; and those who remove from other parts to plant there will unavoidably be of different opinions concerning matters of religion, the liberty whereof they will expect to have allowed them, and it will not be reasonable for us, on this account, to keep them out, that civil peace may be maintained amidst diversity of opinions, and our agreement and compact with all men may be duly and faithfully observed.*[200]

This article gave the right for anyone, including religious dissenters and Jews, to worship according to their beliefs without fear and also tolerance to Native Americans who were unfamiliar with Christianity. Even those enslaved had the right to worship as they saw fit, but that did not alter their state of enslavement:

> *Since charity obliges us to wish well to the souls of all men, and religion ought to alter nothing in any man's civil estate or right, it shall be lawful for slaves, as well as others, to enter themselves, and be of what church or profession any of them shall think best, and, therefore, be as fully members as any freeman. But yet no slave shall hereby be exempted from that civil dominion his master hath over him, but be in all things in the same state and condition he was In before.*[201]

Article 110 made it clear: "Every freeman of Carolina shall have absolute power and authority over his negro slaves."[202]

With a constitution written, the Lords Proprietors began preparing three ships to sail to Port Royal Sound to start a settlement there. In August 1669, the *Carolina*, the *Port Royal* and the *Albemarle* left England under the command of Joseph West. The *Carolina*, a frigate and the largest of the three ships, had ninety-two colonists onboard along with nineteen crewmen. The *Port Royal* was listed as a frigate as well and had seven crewmen onboard, while the *Albemarle* was a sloop that had five crewmen.[203] Frigates were built for speed and seaworthiness, while the sloop was the next class down from the frigate.[204]

After a stop in Ireland, the ships headed for Barbados, arriving there on November 2. One of the items the Lords Proprietors sent with the fleet was a commission for a governor. The place where the name of the governor was to be written was purposely left blank, and when the fleet arrived in Barbados, Sir John Yeamans was instructed to either fill in his name or that of someone else he thought should serve as governor.

While the fleet was in Barbados, a storm wrecked the *Albemarle*, and it was replaced by the sloop *Three Brothers*. When the ships left Barbados, they made a stop on Nevis, where they found Dr. Henry Woodward. He was informed about the expedition to Carolina and decided to join them. After leaving Nevis, a storm separated the ships; the *Three Brothers* ended up in Virginia, and the *Port Royal* ran aground in the Bahamas. The people onboard were able to secure another ship, which took them to Bermuda, where they found the *Carolina*.

Captain William Hilton and the Founding of Hilton Head Island

While in Bermuda, Yeamans withdrew from the expedition and appointed William Sayle as governor. Sayle was once the governor of Bermuda and was seventy-nine years old when he was appointed governor of the Carolina colony. The expedition acquired another ship to replace the *Port Royal*, and it and the *Carolina* left Bermuda together and were the first of the ships to reach Carolina. They put in at Bulls Bay, just north of the Charleston peninsula, on March 5, 1670. After contacting the Native Americans in the area, the colonists let it be known that they were interested in settling in the Port Royal Sound area. They were informed that another group of Native Americans called the Westo had attacked that area. The Native Americans told them

> that ye Westoes A ranging sort of people reputed to be the Man eaters had ruinated [that] place killed seu'all of those Indians destroyed & burnt their Habitations & that they had come as far as Kayawah doeing the like there.[205]

The Westo were feared not because of their reputation as man eaters but because they had firearms. They "doe strike a great feare in these Indians havinge gunns & powder & shott & doe come vpon these Indians heere in the tyme of their cropp & destroye all by killinge Caryinge aweye their Corne & Children & eat them."[206]

Despite this information, the group decided to sail down to Port Royal Sound anyway. Apparently, the opening to the sound was not described well by Sandford, since it was not what they were expecting. But they were able to spot Hiltons Head and use it to successfully enter the sound. While in the sound, they described seeing manatees, which they described as a "small kinde of whale white about ye head & Joule is very plenty in the Riuer."[207]

After two days at anchor, they were able to speak with some of the Native Americans in the area, who did confirm what they had been told about the Westos. They then sailed up to the Combahee River and anchored. The Native Americans in the area were apparently glad the English had arrived and wanted the newcomers to help protect them from the Westos. They called out, "Hiddy doddy Comorda Angles Westoe Skorrye," which the English translated as "English very good friends Westos are not."[208]

The English went on shore and observed the land and wrote down their thoughts:

> [Y]*e Land was good land supplyed with many Peach trees, & a Competence of timber a few figg trees & some Cedar here & theire & that there was a mile & a halfe of Cleare Land fit & ready to Plante.*[209]

At this point, it was decided to send the sloop up to Kiawah to view the land there. When it returned, the crew reported that the land there was better than in the Port Royal Sound area. The colonists now had a decision to make,

> *whether to remove from St Hellena theither, or stay some were of opinion it were more prudent forthwith to Plant prouisions where they were then betake themselues to a second voyage though small it would not proue a better change…the Gouernor adhearing for Kayawah & most of us being of a temper to follow thoug wee knew noe reason for it.*[210]

The ships sailed up Charleston Harbor and then up the Ashley River in April 1670. The colonists settled at Albemarle Point and would call their community Charles Towne. By having their settlement located several miles upriver in a defensible area, the English knew it could be well defended from attack by the Spanish or Native Americans. Ten years later, in 1680, the town moved to a peninsula between the Ashley and Cooper Rivers and would later become known as Charleston.

The decision to settle there instead of Port Royal might have had something to do with the presence of the Westo in that area. The Westo, also known as the Rickahocans in Virginia and Chichimecos by the Spanish, had been driven out of the Northeast by the Iroquois. When they had settled in Virginia, the Virginians had begun trading guns with them in exchange for slaves. Using these superior weapons, the Westos raided other Native American villages and captured anyone they could sell as slaves and killed the rest. They migrated down to the Savannah River around 1660 and in 1661 attacked the Guale and Mocama Indians and a Spanish mission near what is today Darien, Georgia. This attack was probably a slave raid, and when the Indians in that area saw some of their people being captured alive, it seems they thought they were being taken away in order to be eaten.

In 1662, the Westo attacked the Native American town of Huyache, possibly located near the mouth of the Savannah River. A few years later, in 1667, it appears that the Westo attacked villages in the Port Royal Sound area. In the summer of that year leaders of both the Santa Elena and Abya Indians suddenly showed up in Santa Catalina, which was the

northernmost town of the Guale in Georgia. They petitioned the Spanish for permission to settle in their territory and be given land. Dr. Henry Woodward was probably taken down to Guale when the Santa Elena Indians moved there in August 1667. That is most likely when he was taken into custody by the Spanish.[211]

In addition to the presence of the Westo, the English might have also been leery of Port Royal's proximity to the Spanish in St. Augustine and their missions on the Georgia coast. When the *Three Brothers* left Virginia and headed south to join the other ships, it sailed past South Carolina and landed on St. Catherines Island in Georgia on May 15, 1670. The Spanish still operated a mission there called Santa Catalina de Guale, and the arrival of an English ship was not welcomed. For three days, the English traded peacefully with the Native Americans, and the captain and several others went ashore and said they would be back before the next tide. When they did not return, the crew called to them, but there was no answer. The next morning, they heard

> *a drume, & p'sently saw 4 Spaniards Armed with muskets & swords, with ye drume came downe one of these & standing behind a tree holding forth A white cloath hailed us & bid us yield & submit to ye soueraignty of Sto Domingo & told us it were better soe for* [our] *Capt was in chaines.*[212]

The English told the Spanish that they would leave in peace if their fellow countrymen were returned. The Spanish declined, and giving "ye word to some in ye wood Indians & Spaniards wee receiued a volley of musket shott & A cloud of Arrows."[213] Once the wind picked up, the Englishmen were able to sail out of range. Luckily for them, nobody was hurt, but the sails had been damaged. The next morning, they decided to sail up the coast. When they dropped anchor, four Native Americans in a canoe came and told them they were at Edisto and that Shadoo would speak with them. A messenger was sent, and Shadoo and Alush, along with several others, came onboard. Shadoo told them that two English ships had been at Port Royal and that they were now at Kiawah. The next morning, the *Three Brothers* made it to Kiawah and was reunited with the other colonists.

A sloop was sent back to St. Catherines Island with letters for the Spanish governor and the friar at Santa Catalina de Guale demanding the release of the English. Against orders, several of the Englishmen went ashore and were told that their fellow countrymen were at St. Augustine. Supposedly, they were not prisoners but had freewill in the town and were being entertained

at an Englishman's house there. The friar detained two of the Englishmen, and when those on the sloop heard from the Native Americans that three ships were being sent from St. Augustine to intercept them, they decided to leave. Thus, two more Englishmen were now in the hands of the Spanish, and it appears that no more attempts were undertaken to secure them.[214]

The Spanish now knew about the English settlement on the Ashley River and were determined to drive these intruders from what they considered their territory. In August 1670, Native Americans friendly with the English settlers warned them of an imminent attack by three Spanish ships and a large number of Native Americans allied to the Spanish. It was reported that about one thousand Native Americans came to help defend the English settlement, but no battle was fought. A storm drove the Spanish ships away, and their Native American allies, who were going to attack by land, also left, being frighten of the cannons on land and on the *Carolina*, which had just arrived with provisions from Virginia.[215]

With the signing of the Treaty of Madrid in July 1670, Spain formally recognized all the English lands in the Western Hemisphere that Great Britain had settled. This included the settlement on the Ashley River at Albemarle Point and islands in the Caribbean. It also ended a fifteen-year-long conflict with Spain. In 1655, during this conflict, English forces had tried to invade Hispaniola (Haiti/Dominican Republic) but had failed. They next turned their attention to Jamaica, which they successfully captured. Thomas Modyford was made governor and sanctioned privateers to attack the Spanish. One of the more notable of these privateers was Henry Morgan, who not only attacked Spanish shipping but also attacked cities in Cuba, Panama and Venezuela.

The treaty laid out the areas in North America that belonged to the English and the Spanish. The English would have everything north of Charleston, South Carolina, and the Spanish would have everything from Florida north to Port Royal Sound. Despite this demarcation of territory, the English would begin to encroach into Port Royal Sound and eventually Georgia.[216]

6
THE FOUNDING OF HILTON HEAD ISLAND

THE EARLY YEARS

The history of the founding of Hilton Head Island is somewhat hard to ascertain. The first inhabitants of the area were Native Americans, and while evidence of their later occupation of Hilton Head Island can be found in the archaeological record, much of their early history is missing. Around 12,000 BC, when these early people were here, the sea level was four hundred feet below where it is today. When the climate warmed and the glaciers melted, the sea level rose and any evidence of these early Native Americans became submerged by the rising ocean. However, evidence of these early people exists elsewhere, enabling us to surmise what life was like for them in the Hilton Head Island area.

In order to better study the Native American past before European contact took place, archaeologists have divided the time they lived in the Southeast into five general periods. The oldest of these periods is the Pre-Paleoindian or Pre-Clovis period. A number of archaeological sites in North and South America have yielded evidence of native people being there much earlier than previously thought. Meadowcroft Rockshelter in Pennsylvania and Cactus Hill in Virginia are prime examples of sites that have provided evidence of human occupation from around 14,000 to 18,000 BC. In South Carolina, the Topper site in Allendale has yielded controversial evidence of human existence dating back at least fifty thousand years or about thirty-eight thousand years before people were previously thought to have been there.[217]

The Paleoindian period began around 12,000 BC and lasted until 8,000 BC. These people are thought to have been the descendants of people from Asia who arrived in North America across a land bridge that formed between Alaska and Siberia around 14,000 BC. In South Carolina, as in other places, they were nomads roaming over the countryside, hunting, fishing and gathering wild plants, nuts and berries to eat. They hunted large game animals, including the wooly mammoth, with spears that had long, fluted, chipped-stone projectile points that have been called "Clovis" points after the town of Clovis, New Mexico, where they were first found. At this time, the climate was much colder than it is today and has been compared to that of modern-day upstate New York.

At around 8,000 BC, the climate began to change, and the ice age that characterized the previous period was over. The environment began to resemble that of today. The Archaic period (8,000 to 3,000 BC) saw the continuation of hunting and gathering, but a change to the shape of the spear points occurred along with the introduction of the atlatl (spear thrower). Ground and polished stone artifacts and pots made of stone and clay began to make an appearance. During this period, long-distance trade with other Native Americans also started.

The Woodland period (3,000 BC to AD 1670) saw an increase in agriculture, which led to Native Americans settling down in places for longer periods of time. Pots were now being made in an array of forms and sizes and were used for storing, cooking and serving food. Small triangular points were now being made to fit onto arrows with the advent of the bow and arrow. Shell rings began to be constructed along the coast at this time. The shell ring in Sea Pines Plantation on Hilton Head Island dates to around 2,000 BC and consists of hundreds of thousands of oyster, clam and mussel shells deposited in a circle that measures approximately 150 feet in diameter. In the middle was what has been described as a plaza, where archaeologists speculate Native Americans may have lived. Evidence of a structure inside the shell ring at Sea Pines has recently been uncovered, suggesting that Native Americans at this site did indeed live inside the ring. This is one of only fifty shell rings found along the coasts of South Carolina, Georgia and Florida. Hilton Head Island also boasts another shell ring on the north end of the island called Green Shell Enclosure.[218]

From 1000 BC to AD 1520 was the Mississippian period, when Native Americans grew maize, beans and squash and lived in highly populated villages around large earthen mounds with temples on the top. Unlike their

ancestors, the people of the Mississippian period had a more hierarchal society resembling a chiefdom.[219]

When Europeans arrived in the Hilton Head Island area in the sixteenth century, they wrote about some of the different tribes and people they came across. When the English founded Charles Towne in 1670, they too recorded their interactions with the Native Americans. In addition, they also kept written accounts of their activities that have provided a wealth of information about the early history of the colony. Unfortunately, most of the property records for Beaufort County were destroyed during the Civil War or by a fire in 1883, making it hard to piece together the history of Hilton Head Island. However, some information can be found in a variety of other sources, including maps, letters, dairies, newspaper accounts, drawings and photographs.

By the time Charles Towne was founded, Native American populations in the coastal and neighboring areas were declining. Trading with the different tribes for deerskins and slaves was important to the early economy of the new colony since it was getting off to a slow start. Europeans had always been attracted to the New World by the promise of land, and there was abundant land available in Carolina. However, as Samuel Wilson stated in 1682,

> [b]*ut, a rational man will certainly inquire, When I have land, what shall I doe with it? what Comoditys shall I be able to produce that will yeild me mony in other Countrys, that I may be inabled to buy Negro slaves (without which a Planter can never do any great matter) and purchase other things for my pleasure and convenience, that Carolina doth not produce?*[220]

The Lords Proprietors were able to provide the settlers with some definite ideas about what they should do with the land. Mercantilism, the prevailing economic theory in Europe, called for countries to export more than they imported. The Lords Proprietors were hoping the Carolina colonists would be able to provide England with products it could not produce at home such as pitch and tar made from the sap of pine trees. Pitch and tar were used to grease wagon wheels, waterproof cordage and caulk ships. They also hoped the climate in the colony would allow the settlers to grow things like olives, rice, oranges, lemons, tobacco, grapes for wine, indigo to produce blue dyes and mulberry trees for the manufacturing of silk.

However, rice proved difficult, and while indigo could be grown, making dye from the leaves was complicated and difficult. Mulberry trees were

planted, but there were problems with the silkworms; though some silk was produced, the industry never flourished. The settlers soon grew tired of the struggle and, in spite of the disapproval of the Lords Proprietors, decided to copy the colonists in New England and send provisions and lumber to Barbados.

Many of the early settlers had come from Barbados and knew that most of the available land there had been cleared to plant sugar cane, leaving little land for cultivating crops and providing pasture for cattle. There also were few trees to supply lumber for erecting buildings or making barrels, carts and wagons. The settlers in Carolina began to grow fields of corn and peas and to cut trees for lumber to export to the Caribbean. While trade with the West Indies would always play an economic role in the Carolina colony, it would never earn the large profits the colonists wanted. It did lead, however, to the most profitable economic venture of the seventeenth century, the livestock industry.

It was the custom for farmers to let their livestock roam freely to forage for food, thus sparing owners the task of feeding the animals year-round. The colonists soon found that in settling on the outer coastal plain of South Carolina in the low-lying areas made up of pine and hardwood forests, savannas and marshland, they had chosen land perfectly suited to the raising of hogs and cattle.

During the mild winters, cattle were allowed to roam into the marshlands to feed off the leaves of the cane plants before making their way through the hardwood forests to nibble on Spanish moss, an air plant that hangs from the branches of the live oak tree and gives the southern coast its picturesque charm. Hogs were also free to forage for food in the hardwood forests, feasting on the nuts, acorns, roots and wild fruit found on the forest floor.

The pine forests with their understory of shrubs and grasses and the open savannas provided excellent forage for cattle during the warm months while the hogs were content to feed off the pine shoots and roots found in the pine forests. Livestock, then, were able to forage for food the entire year, unlike livestock in the northern colonies.

Since the animals were allowed to roam freely on any unfenced land, a person did not need extensive acreage in order to raise livestock. With only a small investment in some breeding stock, a person with fifty acres of land could establish a sizable herd in a short amount of time. In the early 1670s, there were hardly any hogs or cattle in Carolina, but by the 1680s they numbered in the thousands. In the Port Royal Sound area, many people began to raise livestock. Richard Harris kept cattle on his land on

what is today Williman Island just north of St. Helena Sound. He lived there with eight family members and nine Indian slaves. By 1711, he had sixty cattle, six horses and numerous hogs that were bequeathed to various family members.[221]

Salted beef, along with corn, peas and lumber, were exported to Barbados and other Caribbean Islands. In 1680, ten years after the founding of the colony, settlers exported four tons of salted beef to Barbados. Several prominent Carolina families owed their initial economic success to the livestock industry.

The other profitable industry during the early years of the colony was trading with the Native Americans. Slaves and deerskins soon became the most lucrative commodities offered for trade. Coastal tribes brought their captured enemies to trade to the settlers, who promptly sold them into slavery in the West Indies or locally. The slave trade was profitable for a time, and then deerskins became the favored commodity. While the trade in deerskins had been lucrative in the seventeenth century, an event in Europe in the early eighteenth century made deerskins, for a time, the single most valuable export from the colony. That event was a cattle plague.

Beginning in 1709, an outbreak of rinderpest, a highly contagious viral disease, occurred in Europe. It affected mainly cattle, and with no known cure at the time, it killed an estimated three million cattle within eight years. The only recourse was to contain the disease by slaughtering all the infected animals and any animals they had come in contact with. No part of the infected cattle could be used, as the virus was able to survive for some time in unburied carcasses and hides.[222]

This adversely affected the beef industry and others businesses, such as leather manufacturing. Suddenly, there was not enough leather available for making items such as shoes, belts, gloves, harnesses and bags. Therefore, the trade in deerskins became of paramount importance. Between 1699 and 1715, it has been estimated that an average of fifty-three thousand deerskins per year were exported to Great Britain.[223]

With the declining population of Native Americans in the coastal areas, the colonists realized they might have to look to the western part of Carolina for tribes that were more numerous to trade with. In October 1674, an opportunity to do just that presented itself when Henry Woodward received word that "strange Indians" had arrived at Lord Ashley's plantation on the upper part of the river that bears his name.[224] Woodward traveled by boat to the plantation to meet with them. They were Westos, and he did not understand their language but was able to

discern that they wanted him to travel to their village, which was located on the Savannah River near present-day Augusta, Georgia. He agreed to go with them, and when they got in sight of the village, Woodward recorded that he "fired my fowling peece and pistol wch was answered with a hollow and imediately thereupon they gave mee a volley of fifty or sixty small arms."[225]

Woodward was entertained graciously and stayed there for ten days. He understood that the Westos were interested in friendship and was given many deerskins and a young boy who was captured to the north of where they lived. An alliance was made with the Westos, and trading began. The Westos not only traded items they possessed but also acted as middlemen for the western tribes. This trade lasted for about six years, until 1680.

The Westos could not keep up with the colonists' demands, especially for slaves, and began to attack other tribes indiscriminately. Some colonists, not happy with the volume of trade provided by the Westos, thought of possibly turning on them and taking them as slaves. Also, the possibility of breaking the monopoly the Lords Proprietors had on trading by attacking the Westos and opening up private trade to the west was discussed. Woodward opposed this idea, but in April 1680, an embargo was placed on trade with the Westos and a new ally, the Shawnee, was found. The Shawnees attacked the Westos, and over the course of three years, the Westos were almost completely wiped out, with the survivors escaping and joining tribes to the west. After this, the Lords Proprietors lost interest in trading, which opened it up to all who were interested.[226]

About the time the war with the Westos was winding down, thoughts about starting another settlement south of Charles Towne began to be entertained. The Port Royal Sound area was thought to be the best area for this new settlement, even though it would border Spanish territory stipulated by the Treaty of Madrid. Colonists for the new settlement would be Scottish Presbyterians who were being persecuted back in England.

Scottish Presbyterians had supported Oliver Cromwell during the English Civil War, and when the monarchy was restored in 1660, Charles II tried to subjugate them to the authority of the Church of England. Several acts were passed in the 1660s that were designed to do just that. Those Presbyterian ministers who did not adhere were removed or arrested, but services were still held in private. In 1666, a rebellion began against the oppression, but the rebels were defeated at the Battle of Rullion Green.

Lord Ashley, who by this time was the Earl of Shaftesbury, used his position to try to persuade Parliament to be less harsh with the Scots. Several

of them became interested in trying to start a colony in Carolina, but it came to nothing. In 1679, another rebellion occurred when the archbishop of St. Andrews was assassinated. The rebels were defeated at the Battle of Bothwell Bridge, and around 1,200 prisoners were taken, some of whom were destined to be shipped to the Americas.[227]

In 1682, the Lord Proprietors started a campaign to attract religious protestors to Carolina. To this end, they revised the Fundamental Constitutions and made the article about religious tolerance even more attractive. Some Scottish Presbyterians were interested in coming to Carolina, met with the Lords Proprietors and obtained more concessions. In October, the *James of Erwin* set sail from England in order to find a good location for the settlement. It arrived in Charles Towne in March 1683 and from there sailed down to Port Royal Sound. The crew surveyed the area and sounded the channel. They also encountered some Native Americans and traded with them, noting that there were no more than eighty in the area.[228]

On July 21, 1684, the *Carolina Merchant* left Scotland carrying 149 passengers, including 35 prisoners taken during the rebellions. The passengers arrived in Port Royal Sound on November 2, 1684, and began to build a settlement close to present-day Beaufort. That particular location was chosen because it was far enough up the Beaufort River to be safe from a surprise attack by sea—or so it was thought. The town was named Stuart Town in honor of Catherine Stuart Erskine, who was the wife of one of the leaders, Lord Cardross (Henry Erskine). With the establishment of Stuart Town, there was now a buffer between Charles Towne and the Spanish.

A year before Stuart Town was founded, a group of Native Americans called the Yemassee arrived in the area. Originally, the Yemassee lived in central and northern Georgia, but they were driven from those areas by the Westos and their slave raids in 1662. Seeking protection, they settled in the Spanish-controlled areas of Guale and Mocama along the coast of Georgia, where there was a string of missions, and also among the Timucuans near St. Augustine as well as the Apalachee in western Florida. In exchange for living in these areas, the Yemassee had to contribute to the Spanish labor draft.

On April 30, 1683, St. Augustine was attacked by English and French ships under the command of a French pirate named Grammont. After losing one ship and its crew, the pirates left St. Augustine and headed north to resupply. The missions on the Georgia coast proved to be easy targets, and one of the places they raided were the missions in the Guale and Mocama area. They also apparently attacked the Yemassee villages

there. Not long after these attacks, the Yemassee fled north, possibly seeking protection from the English in a less-vulnerable area and perhaps wanting to remove themselves from the labor draft in which they contributed a larger proportion of labor than other groups in the area.[229]

When Lieutenant Captain Francisco de Barbosa embarked on a survey of the Guale and Mocama area between May 27 and June 7, 1683, he noted that the two major towns of the Yemassee were deserted.[230] Along with a census of the population, a map was completed of Spanish Florida at this time. Where Hilton Head Island is located on the map are the words "Pueblo de ynfieles," or "village of unfaithful or pagans," which was most likely where the Yemassee, who were not Christians, had moved.[231]

Both Stuart Town and Charles Towne vied for trade with this new group, but those in Stuart Town eventually won out. Tensions between the two towns were evident when Henry Woodward and others were arrested while passing through the Port Royal area and taken to Stuart Town. They were commissioned by the Lords Proprietors to explore inland and contact the western tribes, which was something that those in Stuart Town were not interested in seeing happen, as they wanted to be the ones to control the Indian trade. He and his party were eventually released and allowed to continue on their journey.

Caleb Westbrook, a local resident, reported that over one thousand Yemassee had moved into the area, and by 1686, there were about two thousand.[232] With an alliance formed, the settlers soon began to trade with the Yemassee for deerskins and slaves. The Yemassee also acted as middlemen for trade with the native groups to the west, filling the role vacated by the Westos, and their quest for slaves would pit them against their former ally, the Spanish.

In March 1685, the Scots and Yemassee conducted a raid into Spanish territory. The Scots encouraged the Yemassee

> *to make war with the Timecho Indians who are Christians and had a Spanish Fryer and Chapell among them which they agreeing to the Scotts furnished them with 23 fyre Arms in order to distroye the sd Timechos that therupom they proceeded and burnt several Towns and in particular the Said Chapell and the Fryers house and killed Fifty of the Timechoes and brought away Two and twenty Prisoners which they delivered to the Scotts as slaves.*[233]

The Spanish retaliated by attacking Stuart Town on August 17, 1686. Three ships filled with Spanish soldiers and their Native American allies sailed up the river. They took the Scots by surprise despite the supposed advantage of the town's location. When the Scots fled, the Spanish spent three days looting the town and then burned it. The Spanish then attempted to attack Charles Towne, but a hurricane forced them to retreat. Not only was Stuart Town targeted but also the Yemassee villages. The Yemassee fled northward and settled on the Combahee and Ashepoo Rivers in order to be close to Charles Towne.

The Yemassee would eventually reclaim the lands in the Port Royal Sound area and would have ten villages there. English settlers from Charles Towne also moved to the area. Since the destruction of Stuart Town left a void in the trading business, these colonists were eager to pick up where the Scots had left off. The late 1690s saw a number of people acquire large tracts of land in the Port Royal Sound area. Thomas Nairne had begun acquiring land in the 1690s on St. Helena Island, and by his death in 1715, he had over 3,600 acres. John Stewart also had 1,000 acres there, and others had land on Lady's Island and Port Royal Island.[234]

On August 16, 1698, John Bayley of Ballingclough in the County of Tipperary in Ireland was made a landgrave. The title of landgrave gave him control over four baronies consisting of twelve thousand acres each for a total of forty-eight thousand acres. One of those baronies included part of Hilton Head Island. Bayley does not seem to have taken up residence on his lands in Carolina, and upon his death, those lands passed to his son, also named John Bayley. He also appears not to have come to Carolina, but on November 9, 1722, he appointed Alexander Trench to dispose of the land.[235] Trench and his wife, Hester, moved to Charles Towne, and he began to acquire some of the land he was to dispose of.

In his will, which was drawn up on January 1, 1730, Trench listed property and land that was to be sold to pay his debts, with the rest going to his son Frederick, since his wife was already deceased. He listed "my Stock of cattle on Trench Island, being only mine upon the island."[236] Trench Island was how Hilton Head Island was identified on several eighteenth-century maps, and by this time, it seems Trench was using the island for his cattle.

Meanwhile, trouble was brewing in Europe. In 1699, King Charles II of Spain, who had no direct heir, was in failing health. The problem of who would succeed him as the king of Spain became of great importance to the leaders of Europe. Archduke Charles of Austria, the son of Leopold I, the Holy Roman Emperor, was put forth as a candidate for the throne.

10. A 1773 map based on the survey of John Gascoigne and Lieutenant James Cook in 1728. *Courtesy of the Library of Congress.*

However, Louis XIV of France was opposed to Archduke Charles and put forth his own candidate, his grandson Philip of Anjou, whose mother was the daughter of the late King Philip IV of Spain. Philip of Anjou was second in line to the French throne. In 1700, before his death, Charles II named Philip of Anjou as his heir provided he give up all claim to the throne of France. Philip became king, but his grandfather Louis XIV refused to remove him from the line of succession.

England and the Netherlands feared that if Philip should in the future become king of France, the union of Spain and France under one monarch would put them both at a great disadvantage. Shortly after Queen Anne ascended the throne of England after the death of William III in 1702, England and its allies, the Dutch and key German states in the Holy Roman Empire, declared war on France. Queen Anne's War, or the War of Spanish Succession, had begun. The fighting, which began in Europe in 1702, spilled over into North America and the West Indies shortly after.

In North America, the English colonists and their Native American allies engaged the French in Canada and the Spanish in Florida. In Carolina, Governor James Moore amassed a strike force to sail against St. Augustine in October 1702. His force consisted of five hundred colonists and three hundred Native American allies sailing in fourteen small ships. The governor commanded the expedition, which had gathered at the southern end of Port Royal Sound. They attempted to attack St. Augustine, but the imposing fort Castillo de San Marcos kept them at bay. When two Spanish ships arrived from Cuba, they retreated to Port Royal Sound and left a detachment at Port Royal Island to guard against any Spanish incursions.

In 1703, the Lords Proprietors, recognizing the importance of Port Royal Sound, ordered lookouts to be posted there to watch for and repel any Spanish invasion. They also requested a Royal Navy frigate to guard Charles Towne, but if it drew more than twenty feet it was ordered to go to Port Royal Sound. During the next three years, the lookout garrison located on Port Royal Island, probably near present-day Beaufort, evolved from a small wooden blockhouse to a two-story blockhouse enclosed by a palisade. By 1706, the garrison had 4 officers and 112 men stationed there. In addition to serving a military purpose, it also served as a meeting place for people in the area.[237] The following year, in 1707, the General Assembly passed an act calling for a lookout post to be located on the southern end of present-day Pinckney Island, which is adjacent to Hilton Head Island.[238]

Since the garrison on Port Royal Island was being used routinely as a meeting place, the colonists petitioned the Lords Proprietors to create a town there in 1709. The Port Royal River (Beaufort River) was explored and sounded to determine the best place to locate it. In 1711, the town of Beaufort was founded and named after Henry Somerset, the second Duke of Beaufort. At first, Beaufort served as a military outpost, but it quickly developed into a port town and was exporting beef, furs and naval stores such as wood for masts along with pitch, tar and turpentine.

The following year, the Carolina colony was split into two different colonies, North Carolina and South Carolina. Since the northern part of the original Carolina colony was far away from Charles Towne, people in that region felt neglected and thus it was decided to split the colony into two parts, each with its own governor. It was about this time that a map was made showing the province of Carolina in three parts. It shows the boundary between North and South Carolina and it continues all the way down to the tip of Florida and west to present-day Texas. It also shows a close-up of the South Carolina coast, and Hilton Head Island is labeled

as "Hiltons Head Island." This is the first reference to it being called by its current name, and even though the name would continue to vary from map to map, it would eventually become permanent.

This map also shows the town of Beaufort along with the different Native American tribes and records the male population of each of them. The closest group to Hilton Head Island was the Yemassee, with 350 men, while the Savanna, which was the name given to the Shawnee, had 150 men and were living near present-day Augusta, Georgia. Considering women and children, the Yemassee might have numbered between 1,050 to 1,400 people and the Savanna 450 to 600. The map also shows the French territory along the Mississippi River and Mobile Bay, where the French had befriended several tribes in an attempt to thwart the expansion and trade of the South Carolinians, whose traders by this time had already reached the Mississippi River.

11. A 1711 map by Crisp, Nairne, Harris, Maurice and Love showing Hilton Head Island by its current name. *Courtesy of the Library of Congress.*

On Good Friday, April 15, 1715, the Yemassee and other tribes, including the Creeks, joined together in a coordinated attack against the colonists in an attempt to drive them out of South Carolina. Tensions between the Yemassee and the colonists had been brewing for some time. In order to ease these tensions, the General Assembly in 1707 passed an act that defined the territory of the Yemassee. No European settlers were allowed to live in their designated territory, and those who were already there had a year to move or they would have to pay a fine. The colonial government reimbursed those who had title to land in Indian territory. However, despite this act, there were numerous violations, and colonists continued to encroach on Yemassee land.[239]

The increased need for deerskins in Europe at this time due to the cattle plague prompted the Yemassee to overhunt the deer, which rapidly depleted the population. Unable to provide enough skins to the traders, the Yemassee began to sink deeper and deeper into debt. Also, the Indian trade started to become more one-sided, as the colonists began to demand more for less, and to make matters worse for the Yemassee, rum was now an integral part of trade practices. In spite of the colonial government placing restrictions on giving alcohol to Native Americans, traders continued to supply their trading partners with rum. Efforts to try to stop this practice were in vain despite the Commissioners of Indian Trade in 1713 ordering a search of all Yemassee villages and the destruction of any alcohol found there.[240]

Captain Thomas Nairne, who was the official assigned to the Yemassee by the Commissioners of Indian Trade, began visiting the Yemassee in order to smooth things over and better regulate trade. It was generally thought that the problems with the traders and the Yemassee were

> *attributed to some ill Usage they had receiv'd from the Traders, who are not (generally) Men of the best Morals; and that no doubt of it, might give some cause to their Discontents; to which may be added the great Debts they owed the Inhabitants, which it is said amounted to near 10,000 [£] Sterling.*[241]

The Yemassee had other complaints to make against the colonists. They objected to the encroachment of the colonists onto their land, the theft of their goods, excessive labor demands, beatings and murders. They were also worried since they were told that if they could not pay their debts that the traders would "take payment by making them slaves of the debtors themselves, and their children and wives, and carry them off for sale to the

other places."[242] In addition, they objected to how the traders would get them "drunk with strong drinks, and afterwards kill those who were men at arms, and carry off the women and children in order to embark them and carry them for sale."[243] All this came to a head on Good Friday.

A few days before, a rumor of an attack by the Creeks forced the colonial government to send agents out to meet with the different tribes. One group, which included Thomas Nairne, went to the main town of the Upper Yemassee and appeared to smooth things over:

> *At night they went to sleep in the round-house, with the King and chief War-Captains, in seeming perfect friendship; but next morning, at break of day, they were all killed with a volley of shot, excepting one man and a boy, who providentially escaped (the man much wounded) to Port-Royal, and gave notice of the rising of the Indians to the inhabitants of St. Helen's.*[244]

Not all the colonists were killed right away; some were taken prisoner and killed later. Thomas Nairne ended up being tortured to death over several days by having burning splinters inserted into his body. However, two members of the party escaped, including

> *one Seaman Burroughs, a strong robust man, seeing the Indians' cruel barbarity on the other gentlemen, made his way good through the middle of the enemy, they pursuing and firing many shot at him. One took him through the cheek (which is since cured) and coming to a river, he swam through, and alarmed the plantations.*[245]

Thanks to Burroughs, about three hundred residents of Beaufort were able to flee to a smuggler's ship that had been impounded. The cannons onboard were used to keep the attackers away, and the ship safely made its way to Charles Towne. The Native Americans then ransacked the town, burned homes and destroyed cattle. They also raided plantations in the area and killed anyone they found. While this attack was going on, another group was attacking settlements to the north, and those who were not killed or taken prisoner fled to Charles Towne.

Over the next several months, the militia was able to drive the Yemassee from South Carolina. The Yemassee eventually settled along the Georgia coast and met with the Spanish governor in St. Augustine to request a pardon for past hostilities. The pardon was granted, and they were allowed to live around St. Augustine.

For the next thirteen years, the Port Royal Sound area saw sporadic attacks by the Native Americans. By 1720, Beaufort was virtually uninhabited and the fort was in ruins. However, there were still some colonists who remained in the area. In 1710, Colonel Alexander Mackay acquired part of present-day Pinckney Island, which is located next to Hilton Head Island. He eventually owned the entire island and operated a trading post there. On period maps, this island was referred to as Mackay's Island. In 1715, Colonel Alexander Parris, who was the treasurer of the South Carolina colony, acquired present-day Parris Island, and on December 10, 1717, Colonel John Barnwell was granted one thousand acres of land in the northwest section of Hilton Head Island for his service in fighting the Yemassee.

In order to defend the area, the General Assembly authorized the establishment of additional lookout posts and put in place an early warning system involving a fleet of scout boats. These boats, which were either periaguas—large dugout canoes—or longboats, were about thirty feet long and carried a crew of six plus a commander. They contained a removeable mast and oars and were outfitted with swivel guns. The crewmen aboard the scout boats were expected to patrol the coast and inland waterways watching for any sign of trouble and notifying the inhabitants if they spotted anything suspicious. In addition, they were to be on the lookout for runaway slaves and deserters headed for St. Augustine.[246]

While these patrols were designed to warn those few still living in the area of impending danger, attacks still occurred. In a letter to the Duke of Newcastle, Governor Arthur Middleton related that it "is a very greate discouragement to the settlers of our southern frontiers to be always obliged to hold the plough in one hand, and the sword in the other."[247] He goes on to relate how plantations in the Port Royal Sound area were being attacked:

> *In August 1726, the Governor of St. Augustine fitted out a small party of Cussuba Indians from thence, who came upon Trenches Island (within ten miles of Port Royall) murdered and plundered one Richard Dawson and his wife.*[248]

He also went on to describe another attack on Trench's Island (Hilton Head Island) the following year:

> *On 26th Sept. last the Governour of Augustine fitted out two perriauguas manned with six of our runaway slaves and the rest Indians who came*

> *upon Trench Island and set upon the house of one Alexander Dawson, where they killed and carryed away four children and four men and women. The Indians would have murtherd them all, for the sake of the scalps, but this time the negroes would not agree to it, and the Spaniards themselves told Dawson, when he, together with some of the rest, were carryed prisoners into St. Augustine, that the Governour had agreed with the Indians to give them 30 peices of eight for each white man's scalp and a hundred peices of eight for each negroe.*[249]

It seems that by offering to pay for English scalps and for the capture of African slaves, the Spanish were encouraging the Yemassee and runaway slaves to attack the colonists. Alexander Dawson appears to have survived the attack and was able to relate his story about how the Spanish paid the Yemassee. His probable relative Richard Dawson and his wife appear not to have been so lucky. Besides possibly John Barnwell, the Dawsons may have been some of the earliest English inhabitants of Hilton Head Island.

The attacks continued, and in January 1728, one of the scout boats patrolling the area was surprised by the Yemassee at a lookout post at the southern end of Daufuskie Island. All the men, with the exception of Captain Gilbert, who was taken prisoner, were killed. Since that time, the south end of Daufuskie Island has become known as Bloody Point.[250]

A few months later, on March 9, Colonel John Palmer, with one hundred South Carolina militia and about one hundred Native American allies, attacked the Yemassee at St. Augustine. At dawn, they surprised them and killed thirty, taking fourteen prisoners. Over the next three days, Palmer and company raided the areas outside the Spanish fort, and when the Spanish requested that they stop, Palmer said he would stop if he were given provisions. This was done, and he and his men left. This battle finally put an end to the war, and the remaining Yemassee eventually settled with the Creeks, who had made peace with the English.[251]

Around 1730, James Sutherland, writing about his visit to the Port Royal Sound area, described the lack of people and what he thought was the cause of it. He wrote that there were

> *but a few Stragling houses meanly inhabited, which on the Contrary ought always to have a great many Men to prevent the Pyrates destroying the Country. Here is a very good Harbour but difficult to come into, because of several Sand banks, & is the Southmost Settlement belonging to the English except Hill Town head, where are Fish in abundance but very few*

inhabitants. The People being afraid to settle there, so near the Spaniards of St. Augustin's who are continually encouraging the Indians to destroy them, which makes the croud to the Northward to be under the protection of the Northern Colonies.[252]

In 1728, John Gascoigne and Lieutenant James Cook conducted a survey of Port Royal Sound from which maps were later produced. One of these

12. A 1773 map based on the survey of John Gascoigne and Lieutenant James Cook in 1728. *Courtesy of the Library of Congress.*

maps shows the northwest section of Hilton Head Island, which is named Trench's Island on the map, as a steep area for careening ships, meaning that it was a good place to turn a ship on its side for cleaning or repairing. Next to that area is the name Golgotha, the Hebrew word for "skull," which might be a reference to Skull Creek, which runs in between Hilton Head Island and Pinckney Island. Also shown is John's Island, which was owned by John Gascoigne, who purchased it from Alexander Trench in 1729.

Other interesting navigational markers, in addition to Hiltons Head, are shown on the map. "Balinaclough or Dolphin Head" overlooks Port Royal Sound and was most likely named after John Bayley Sr., who was originally granted the land in 1698 and was from Ballingclough in the County of Tipperary in Ireland. Later, Balinaclough was dropped, and the name Dolphin Head remained. Just south of "Hilton Head" on the map is "Scarborough Head," which is where the Atlantic Ocean and Port Royal Sound meet. It was named after the HMS *Scarborough*, which patrolled the Carolina coast possibly as early as February 1726. Farther south is "Bass Head," which appears to be named after the fish so often caught in the area.[253] These navigational markers, like Hiltons Head, were important landmarks that seamen would be able to use to help them sail into the sound. The fact that several more were added to those already marked attests to Hilton Head Island's importance to sailors at this time.

The year after Gascoigne and Cook conducted their survey, the Lords Proprietors were no longer in control of the colony. At issue were disputes between the colonists and the Lords Proprietors over the colony's economic situation and the colonists' constant demands for protection. Since the Lords Proprietors oversaw the colony from England, the colonists felt their needs were not being sufficiently considered, and the Proprietors thought the colonists were not doing enough to turn a profit. Therefore, the British government took over, and South Carolina became a royal colony.

7

THE FOUNDING OF HILTON HEAD ISLAND

FROM ROYAL COLONY TO RESORT

After fifty-nine years of rule under the Lords Proprietors, South Carolina became a royal colony in 1729 when the last of the Proprietors sold his shares to the Crown. Once South Carolina was under the control of the Crown, South Carolinians were allowed to ship their rice directly to any country south of Cape Finisterre, opening up markets for them in Spain, Portugal and the Mediterranean countries. In 1731, the new royal governor made land in the Port Royal Sound area available to colonists. Now that the Yemassee were gone, the land they were given in 1707 was now opened for settlement. Also, the governor initiated his plan to settle Europeans in frontier areas of the colony, and the Swiss colony of Purrysburg was established in 1734 on the Savannah River.

With new land and new markets opening up, people began to resettle the Port Royal Sound area. When the town of Savannah was founded in 1733, colonists began to feel that the area around Beaufort was a safe place to live, as there was now a settlement to the south to act as a buffer between them and the Spanish. However, naval assaults continued, as the Spanish often attacked shipping in the area. One such incident occurred when Captain Thomas Tucker and his schooner *Tybee* were captured by a Spanish privateer in January 1763 while he was in Port Royal Sound. He and his ship were taken to St. Augustine, where the *Tybee* was seized. Tucker was apparently granted the opportunity to purchase it back along with the slaves onboard and safely returned to Beaufort.[254]

A string of wars culminating with the French and Indian War, called the Seven Years' War in Europe, finally put an end to Spanish rule in Florida. With the signing of the Treaty of Paris on February 10, 1763, Spain turned over Florida and Minorca, a Spanish island in the Mediterranean, to the British. Spain, however, regained control of the Philippines, Louisiana and Cuba. The French, who were allied with Spain, lost Canada and Senegal in West Africa to the British.

Despite some ongoing risks, more colonists began to settle in the southern part of the colony. In 1734, Charles Pinckney purchased Mackey's Island and would also acquire several smaller adjacent islands. He was a lawyer who had been elected to the Commons House of the General Assembly in 1731. He did not live on what would become known as Pinckney Island but instead resided at his plantation outside of Charles Towne. He appears to have used the island to grow produce that was sold in Beaufort and Savannah and exported to the West Indies. Rice appears to have been attempted as well, but the presence of so much salt water most likely hampered this endeavor.[255]

In 1739, Benjamin Whitaker, who was the executor of Alexander Trench's will, advertised the following land for sale in the *South Carolina Gazette*: "Together or in Parcels two Baronies, one lying in Granville County, commonly called Trench's Island, or Hilton Head."[256] A year later, in 1740, two hundred acres of land, originally purchased from Trench, was being offered for sale on Hilton Head Island.[257] Despite the availability of land on Hilton Head and the other sea islands, most colonists wanted land farther inland, where they could grow rice far away from the presence of salt water. They chose to settle instead along the Combahee and Coosawhatchie Rivers, which were ideal areas for growing rice.

Rice was one of the first crops the settlers had tried to grow in the early years of the colony, but they had found it difficult and many had given up on it. It was not until 1690 that Carolinians began to experiment with rice production in earnest, and with the help of slaves imported from the rice-growing areas of West Africa, they began to learn the proper techniques for raising, harvesting and threshing the grain. By 1700, a substantial amount of rice was being exported from the Lowcountry of South Carolina, and by 1712, rice growing had replaced livestock as the chief agricultural industry.[258]

Once land for rice growing was purchased, it needed to be prepared for cultivation. This required a large labor force, and since Native American slaves were no longer readily available, African slaves became the primary labor force. The slaves had to not only prepare the land but also do all the

planting, harvesting and weeding. As one writer noted, the cultivation of rice was "dreadful":

> [F]or if a work could be imagined peculiarly unwhole[s]ome, and even fatal to health, it mu[s]t be that of [s]tanding, like the negross, ancle, and even mid-leg deep in water, which floats an ouzy mud; and expo[s]ed all the while to a burning [s]un, which makes the very air they breathe hotter than the human blood; the[s]e poor wretches are then in a furnace of [s]tinking putrid effluvia: a more horrible employment can hardly be imagined.[259]

The use of African slaves began to transform the Port Royal Sound area from one that was mostly populated with Europeans and Native Americans to one that was mainly populated by African slaves.

The overproduction of rice caused its price to drop in the 1740s, and the War of the Austrian Succession, which began in Europe in 1740, disrupted markets there. With freight costs going up because of the war and the price of rice going down, South Carolinians needed another product that would help sustain them through this economic downturn. That product would be indigo.[260]

In 1739, Eliza Lucas began to experiment with growing indigo on her father's plantation near Charles Towne. She not only experimented with growing the plant but also with how to extract the blue dye from its leaves. This blue dye was much sought after by the textile industries in England for dyeing cloth, especially the wool for the blue uniforms of the Royal Navy. At this time, England was importing most of its indigo from the French islands in the Caribbean but was very interested in having its own colonies produce it.

Like rice, indigo production had been tried in the seventeenth century in South Carolina, but, while getting the plant to grow was not difficult, extracting the dye was a very tricky and precise process. Eliza's father, who was an officer in the British army stationed on the island of Antigua, sent her the seeds from the West Indies. He wanted a viable second cash crop to grow on his plantation. Indigo would fulfill that need.

Once Eliza had a good crop growing, she then needed to tackle the task of extracting the blue dye. In order to help with this, her father sent her an experienced indigo maker from the island of Montserrat in the West Indies. His name was Nicholas Cromwell, and he was supposed to teach Eliza all about the indigo making process, but in fact he showed her very little.

The indigo he made was practically worthless, and he was overheard telling another worker that he did not want indigo from South Carolina to compete with indigo from his native island of Montserrat. When the term of his contract was over, he was sent back to Montserrat. The only person Eliza's father could find to replace him was his brother, Patrick Cromwell. However, Patrick proved to be more competent than his brother and produced several pounds of good dye.

The first step in making the dye was to cut the stalks and leaves from the indigo bushes. They were then gathered together in bundles and put in the first of a series of three large vats. Each vat was built on a platform, with each vat lower than the one before it. The bundles of stalks and leaves were placed in the top vat and covered with a mixture of water and urine. Since the bundles would float on top of this mixture, large, flat boards were placed on top of them to hold them down.

These bundles were left to soak in this mixture for eighteen to twenty-four hours. During this time, the leaves began to break down or rot due to the presence of the urine and released their blue color into the surrounding liquid. The mixture would begin to ferment, blue bubbles would start to appear and a blue froth would begin to rise in the corners of the vat. This was the most critical time; the indigo maker had to watch the vat very carefully, and when, in his judgment, the bubbles were appearing fast enough and the color of the froth was just right, it was time for the next step.

The liquid from the first vat was drained into the lower second vat, leaving the rotting stalks and leaves behind. The liquid in the second vat was then beaten by workers, who stirred it with wooden paddles to get air into the mixture. This beating lasted about twenty to thirty minutes or until the liquid turned a deep green and there were small, blue muddy grains floating in it. At this time, lime water was added to the mixture. The lime water was made by mixing burnt and crushed oyster shells with water. After the lime was added, the mixture was beaten again. Slowly, a clear liquid rose to the top, and a blue, mud-like sludge, which contained the dye, sank to the bottom.

The clear liquid was drained off and the mud transferred to the third and lowest vat to drain. The drained mud was then worked by hand until it was smooth and pressed into boxes and cut into squares, the shape of a domino. They were referred to as indigo bricks. The indigo bricks were then placed in the drying house to dry before they were packed in barrels for shipment. The whole process from beginning to end took three weeks.

In 1744, while she was experimenting with indigo, Eliza married Charles Pinckney. It was Charles who sent six pounds of Patrick Cromwell's dye

13. A 1667 engraving showing the indigo making process in the West Indies. *Courtesy of the Library of Congress.*

back to England to see how well it would be received. The verdict was favorable. The dye was pronounced to be just as good as the French dye. Eliza saved most of that year's crop for seed, which she gave out to anyone who would agree to plant it. In 1747, 135,000 pounds of indigo bricks were exported to Great Britain. The following year, Great Britain began paying a bounty, or a stipend, of six pence per pound on indigo produced in British North America and shipped directly to England. That led to an increase in production, and in 1775, over one million pounds of indigo bricks were exported from South Carolina.[261]

Indigo was the perfect complement to rice since it grew well on the high ground between the marshy areas where rice fields were located. Both rice and indigo were labor-intensive, but indigo dye could be made before the rice needed to be harvested when the fields were flooded. This meant that a plantation owner did not have to acquire additional labor for indigo. The same labor force that cultivated rice could also be used to work with the indigo.

The sea islands around Port Royal Sound became a good place to grow indigo, especially since growing rice in those areas was not practical. The indigo plant grew well in the sandy soils there, and the plants were susceptible to frost, making the warmer temperatures near the coast ideal. Some, like Nathaniel Barnwell, made a fortune by growing indigo on the sea islands. At his death in 1775, Barnwell owned three thousand acres of land, two

plantations, two townhouses in Beaufort, eighty-nine slaves, 147 head of livestock and six sets of indigo vats and pumps.[262]

John Chaplin, on the other hand, represented the more modest land owner to populate the sea islands. He owned 1,700 acres on St. Helena Island, and possibly one of his brothers also owned a 400-acre plantation on Hilton Head Island. When John died in 1776, his inventory revealed that he had indigo vats, indicating that he was making indigo dye. He also had a small herd of cattle and hogs as well as furnishings for his house, fishing equipment and three volumes of *Arabian Nights*. His labor force consisted of seven slaves, of which only two were adults.[263]

A map of Port Royal Harbor published in 1766 stated that there were thirty families and one church on St. Helena Island and that they produced indigo there. No doubt one of those families was Chaplin's, but it also stated that there were twenty-five families living on Hilton Head Island. It is likely that one of the Chaplins was living on Hilton Head Island around this time and might have been producing indigo like his relative on St. Helena.

In 1769, there were several newspaper advertisements for public auctions of the estates of those who had plantations on Hilton Head and were deceased. These advertisements demonstrated that there were people growing indigo there. The possessions of Nathaniel Adams that were being auctioned included "nineteen valuable Slaves, with a few Household Goods, two Canows [canoes] and two [s]etts of Indico Vats."[264] Joseph Parmenter's items to be auctioned included

> *The stock of cattle, hogs indico vats, provisions, and on Thursday the 7th of December next, will be sold at the useful place, in the town of Beaufort, about 13 negro Slaves, belonging to the above estate.*[265]

As noted in these auctions, slaves were also part of the property that was to be disposed of. This was an anxious time for those who were enslaved since they did not know what their fates would be. Families could be broken up and sold to different owners without the likelihood of their ever seeing one another again. When Daniel Williams died, items at his Hilton Head Island plantation that were to be auctioned included

> *a stock of cattle and hogs, feather beds and houshold furniture, &c. Also on the Thursday following, at Beaufort, some Negroes belonging to the said deceased, among whom are good oar men, sawyers a good cook, and handy boys and girls.*[266]

14. A 1766 map by James Cook stating that there were twenty-five families on Hilton Head Island. *Courtesy of the National Library of Australia.*

Whether these "handy boys and girls" were sold with their families or not is unknown, but many slaves tried to escape to freedom to ensure they would never be bought or sold again. Plantation owners who had runaway slaves would often take out ads in the newspapers offering a reward for their return. Several owners on Hilton Head Island placed such ads for the return of their slaves.

John Rogerson took out a runaway slave ad in 1748 for "two Negroes, a Man and Woman, named Harry and Maria; the Man is little lame and speaks good English." He was offering a five-pound reward plus expenses for their return.[267] In 1768, Samuel Green placed an ad that read,

> *Run-Away from my Plantation at Hilton-Head, some Time ago, a Mustee* [mixed race] *Fellow, named July, has long straight Hair, well made, and about 40 Years old, had on when he went away white Negro Cloth Cloaths, his Coat cuffed with Blue. Whoever will deliver him to me at Hilton Head, shall be handsomely rewarded.*[268]

Edmund Mathews had a sixteen-year-old slave boy "named Darby, formerly called Quackor, of the Guinea country," run away in 1770.[269] Three years later, in 1773, George Russell took out an ad that stated,

> *Run-Away, about two months ago, a Negro man, named Quash, a ship carpenter by trade, had on when he went away a blue negro cloth jacket and trowsers. He is well known in Charles-Town and on James's Island. As it is probable he may endeavour to hire himself to work at his trade, all persons are hereby forbid harbouring or employing him. He is country-born, speaks good English, is a very black fellow, middling well made, and about five feet six or eight inches high.*[270]

Since the population of Hilton Head Island was beginning to increase, it was made a part of St. Luke's Parish in 1767. The Church Act of 1706 had divided the colony into ten parishes and established the Church of England as the official church of Carolina. In 1712, the South Carolina General Assembly created St. Helena's Parish, which covered the Port Royal Sound area.

When the population began to increase, St. Helena's Parish was divided two more times, and in 1767, it was divided a third time when St. Luke's Parish was created. Each parish chose seven vestrymen who would appoint a sexton and a clerk for the church in their parish. The vestry oversaw the recording of births, deaths and marriages and constituted the only form of local government.

About this time, shipbuilding had become an important business in South Carolina, with Charleston, Georgetown and Beaufort leading the way. In a ten-year period between 1764 and 1774, at least thirty ships were built in the Port Royal Sound area. In 1765, there were ten shipbuilders in the area who built ships that averaged about seventy tons, with many over one hundred tons. No shipyards have been located in the Port Royal Sound area, but it seems that these shipbuilders built their ships, especially the larger ones, on the sea islands since they provided deep-water access and were close to the trees needed for construction.[271]

The wood from live oak trees was the preferred wood for shipbuilding. It was used for the ships' main timbers because the wood was very dense and not susceptible to rot. Yellow pines were also highly favored for use in making the planking and decking. The September 28, 1765 edition of the *South Carolina Gazette* noted that

> *as soon as the superiority of our Live-Oak Timber and Yellow Pine Plank, to the timber and plank of the Northern colonies, becomes more generally known, 'tis not to be doubted, that this province may vie with any of them in that valuable branch of business.*[272]

Robert Watts, a shipwright who moved from Philadelphia to South Carolina, used at least two locations for constructing his ships. The first location was Bloody Point on Daufuskie Island, where he built the 170-ton ship *St. Helena* in 1766 and the 260-ton ship *Friendship* in 1771. He also appears to have used Skull Creek, which runs between Hilton Head Island and Pinckney Island, in 1773 to build a 420-ton ship—the largest vessel constructed in colonial South Carolina. John Gascoigne and Lieutenant James Cook's 1728 survey of Port Royal Sound noted a place on Hilton Head Island next to Skull Creek that was a good place to careen ships. This may have been the site used by Watts to build the 420-ton ship.

Enoch Laurens and John Russell also built ships on Hilton Head Island and constructed a 260-ton brigantine aptly called the *Live Oak* in 1775.[273] John Russell might have been related to George Russell, who owned a slave trained as a ship's carpenter who ran away. It is likely that the Russells, and possibly others, used skilled slave labor to help construct ships on Hilton Head Island.

Not all land on Hilton Head Island was taken up at this time with indigo and shipbuilding. There were still large portions of the island in the hands of the descendants of John Bayley; they were trying to sell or rent it. In order to do this, an ad was placed in the *South Carolina Gazette*:

> *To be Let for Ten Years, from January, 1772 Several Thousand Acres of Land, on Hilton-Head Island, exceeding good for Indico, &c. part of the Estate of John Bayly Esq.*[274]

Also, around this time a large fully developed plantation on Hilton Head Island was going to be auctioned off. It was described as

> *that very valuable Plantation on Hilton Head, containing by Survey 990 Acres; almost the Whole of which is choice Indico Land, and reputed the best Plantation in that Part of the Country. On the Premises is a very good Dwelling House, Barn, and every necessary Out-Building.*

In addition to the property, "the Stock of Cattle on the Plantation at Hilton Head, consisting of about 200 Head, about 100 Head of Sheep, some Hogs, and about 400 Bushels of Corn" was being auctioned off.[275]

With the onset of the American Revolution in 1775, Great Britain stopped paying a bounty for indigo from the American colonies now in revolt. In addition, the revolutionary government imposed an embargo on exports to Great Britain. On December 6, 1775, the Council of Safety ordered that shipments from Beaufort of indigo and anything else that might benefit Great Britain be halted. This was a big economic blow to Hilton Head Island and the other sea islands since they primarily grew indigo for export to Great Britain. As a result, plantation owners began to smuggle indigo out of South Carolina in order to earn some money. The numerous creeks and private landings around the sea islands made it hard for officials to catch anyone in the act.

Even though rice was exported to Great Britain, the South Carolina Delegation to the First Continental Congress in Philadelphia negotiated its exclusion from the embargo. They argued that barring rice would be too much of a financial hardship for those in South Carolina, but apparently banning the export of indigo to Great Britain was acceptable. In order to try to alleviate the economic hardship of indigo growers and others, a plan was devised to save one third of the rice crop to compensate those whose crops were banned from export.[276]

Also of concern was the possibility that royal officials in South Carolina might use their Native American connections to persuade the Cherokee and Creek to attack the frontier. This fear was realized in July 1775 when the South Carolina Council of Safety discovered that gunpowder was being shipped to Savannah in order to supply the Native Americans. The council ordered that two barges be sent to Bloody Point on Daufuskie Island in order to intercept the shipment. While at Bloody Point, the barges were joined by the schooner *Liberty*, and the Americans were able to successfully capture sixteen thousand pounds of gunpowder along with arms, shot and lead.[277]

Realizing Charleston's importance as a port, the British tried to attack it early in the war. On June, 28, 1776, the Royal Navy under command of Commodore Sir Peter Parker attacked an unfinished fort on Sullivan's Island constructed of palmetto logs and sand with nine British men-of-war. After a nine-hour battle, Sir Peter Parker ordered the withdrawal of his ships, and Charleston was saved. The fort was then named after the commander, Colonel William Moultrie, and became Fort Moultrie.

In December 1778, Savannah, Georgia, was captured by the British, and in late January 1779, the British attacked the Port Royal Sound area. A small fleet of privateers and longboats arrived in Port Royal Sound towing a large ship that was used as a floating battery. On their way up from Savannah, the British burned and looted plantations on Hilton Head Island along Skull Creek and carried off numerous slaves.[278] Their objective was to capture or destroy Fort Lyttleton, located just south of Beaufort. When the Americans found out the British had landed, the defenders at Fort Lyttleton decided to spike the cannons and destroy the bastions before retreating.[279]

Having discovered that the Patriots had destroyed their garrison at Fort Lyttleton, the British decided to take advantage of the opportunity to capture all of Port Royal Island and gain control of the largest deep-water port south of Philadelphia. They would then be able to anchor a large fleet in the harbor to mount an attack on Charleston.

However, on the march to Beaufort, the British infantry was met by American militia forces under the command of William Moultrie, now a brigadier general. It was the first land battle of the American Revolution to be fought in South Carolina, and General Moultrie's militia units forced the British to withdraw to their ships. The British were thwarted in this attempt to take Port Royal Island, but they would return in July and achieve success.

American and French forces attempted to recapture Savannah in the fall of 1779. On September 4, about a month before the battle began, French ships had been sighted by the British off the coast of the sea islands. The British were not sure if the ships were part of a larger fleet or not, but they were worried that some of the ships might enter Port Royal Sound and cut off communications with Beaufort. British troops in Beaufort were ordered to Hilton Head Island, but the officer in charge was taken prisoner by the Americans while traveling through Skull Creek. As it turned out, the French ships did not stay in the area for long and were soon gone.[280] The Siege of Savannah began about a month later but was unsuccessful, and the British decided that they were now in a position to attempt to capture Charleston again.

The British attacked Charleston and lay siege to the town in March 1780. A six-week-long siege began and ended with the Patriots surrendering the town. In the ensuing years, the British concentrated most of their forces in and around Charleston and Savannah, leaving the Port Royal Sound area alone. Also, there were no Continental troops stationed in the area, and the militia was not effective. As a consequence, people began taking matters into their own hands. Incidents of raids, murder and revenge began to take place

between those on Daufuskie Island, who tended to be Loyalists, and those on Hilton Head Island, who seem to have been Patriots.

By October 1781, members of the Royal Militia on Daufuskie Island led by Captain Philip Martinangel were routinely raiding plantations on Hilton Head Island. One such incident took place at the home of Lieutenant John Talbird, who was at the time a prisoner of war being held by the British in Charleston. His pregnant wife, Mary Ann, was at their home on Hilton Head Island near Skull Creek when she saw British soldiers heading toward her house. They were being led by Isaac Martinangel (probably Philip's brother), who was married to her sister. He ordered the soldiers to remove all the furnishings from the house and place them under a large oak tree before ordering the house to be burned.[281]

The Patriot militia on Hilton Head was anxious to stop these raids, and on October 22, the militiamen thought they had their chance. Having received intelligence that the Royal Militia was planning another raid that night, the Patriots waited at the south end of Hilton Head Island, where they would have the best view of any boats coming from Daufuskie Island. But instead of coming across Calibogue Sound to the south end of Hilton Head, which is the shortest distance between the two islands, the Royal Militia went north and entered Broad Creek.

When the militia reached the head of Broad Creek, they concealed themselves in the woods by the side of the road and waited there to ambush any Patriots who might happen by. Near the spot where they waited was a fence running through the woods that was used to contain wandering livestock. Across the road was a wooden gate known as Big Gate. Anyone traveling down the road would have to stop to open the gate before moving on.

After waiting at the south end of the island for a while, the Patriots figured the information they were given was not correct and decided to head home. Three members of the militia were riding together: Charles Davant, his brother James and John Andrews. At some point, James turned off and went to his home at Point Comfort, while John and Charles rode on. When they got to Big Gate, Charles stopped to open the gate and head toward his home at Two Oaks. That is when shots rang out, and Charles was hit. John escaped unharmed, and a badly wounded Charles was able to ride home.

His wife and young son were apparently able to speak with him before he died, and he supposedly told them that it was Captain Martinangel who had shot him. To avenge his death, the Patriot militia, around Christmastime, went to Daufuskie Island to kill Martinangel. Included in the party was Charles's brother James and John Andrews's brother Israel.[282] The *Royal*

Gazette in Charleston, which was a British newspaper, reported on what happened when the Patriots arrived on Daufuskie Island:

> [W]e are informed from Savannah that about Christmas last, a gang of banditti came to a house on Daufusky Island where Capt. Martinangel of the Royal Militia was lying sick and whilst two of them held his wife another named Israel Andrews shot him dead; they afterwards plundered Mrs. Martinangel and her children of almost everything they had. These wretches came from Hilton-Head; they stile themselves the Bloody Legion, and are commanded by John Leaycraft.[283]

At the end of the Revolutionary War in 1783, Hilton Head Island, along with the rest of South Carolina, was devastated. It was noted that "every field, every plantation, showed marks of ruin and devastation. Not a person was to be met with in the roads. All was gloomy."[284] Some of those who did not fare well were the descendants of John Bayley, whose unsold land on Hilton Head Island was confiscated during the war. However, that land would end up being returned to Benjamin Bayley, one of the descendants. Benjamin, like those before him, tried to sell the land on Hilton Head Island. He enlisted the help of fellow Irishman and local resident Dr. George Mosse. In 1783, Dr. Mosse had the 14,924 acres of Bayley land on Hilton Head Island surveyed and divided up into forty-seven lots and began offering them for sale.[285]

Despite the slow recovery after the war, prosperity would once again return to Hilton Head Island and the other sea islands with the introduction of cotton. In 1790, William Elliot II was able to grow the first successful crop of sea island cotton on his Hilton Head Island plantation, Myrtle Bank. This combined with the invention of the cotton gin, both the roller-type and Eli Whitney's sawtooth-type, made cotton the next cash crop. The cotton gin sped up the process of removing seeds from cotton fiber—which was previously done by hand—and greatly increased the amount of cotton that could be generated. The quantity of cotton exported from South Carolina grew incredibly, and by 1801, over eight million pounds a year were being exported. This made South Carolina the largest cotton producing state in America.[286]

The rise of cotton greatly increased the need for labor. In 1787, a hold was put on the slave trade from Africa, meaning that no more slaves from that continent could be legally imported into South Carolina. At that time, with the country recovering from war and the economy slow, additional slave

labor was not needed. However, with the introduction of cotton, the need for slaves grew, and many planters in the 1790s began acquiring slaves from Africa illegally.

Late in 1803, the South Carolina legislature decided to make the direct importation of slaves from Africa legal again. This caused a huge influx of Africans into South Carolina, and while the country of origin for a lot of them is unknown, there were a number of slaves who were taken from the Angola and Congo regions. It has been estimated that between 1803 and 1808, forty thousand slaves were imported and perhaps twenty thousand more were illegally imported between 1795 and 1804.[287]

This influx of around sixty thousand new slaves directly from Africa to the isolated sea islands gave birth to a new culture called Gullah. Since these slaves were mostly sent to plantations on the sea islands where there were few white people, this group was able to preserve much of their African cultural heritage. They developed a creole language, created many African-inspired crafts such as making coiled baskets out of sweetgrass and had a cuisine based on rice.[288]

Most plantation owners on Hilton Head Island did not live there but instead had homes in Beaufort, Savannah or Charleston. Therefore, the island was mainly populated by slaves and overseers. The houses constructed on Hilton Head at this time tended not to be large plantation houses but more modest buildings. No houses from this period have survived on Hilton Head, but the ruins of a plantation house and the foundations of other buildings still exist in Sea Pines Plantation on the south end of the island.

John Stoney purchased lots 45, 46 and 47, which were laid out by Dr. George Mosse, probably sometime in the early 1790s. Sometime shortly thereafter, he had a house and slave quarters constructed on the property. His brother James appears to have also been part owner by the early nineteenth century. John, a merchant from Charleston, and his brother were buying up land and acquiring slaves. The house that was built on the property measured forty feet, six inches, by forty-six feet, six and a half inches, and was likely one and a half stories tall. It was made out of tabby, which is a concrete-like material made by mixing together sand, ash, oyster shells, water and lime. This mixture was then poured into molds, and when hardened, it could be used to make foundations, walls and other structural features. Stucco was often applied to the walls not only for aesthetics but to protect the tabby from water damage as well.

Not far from the main house is the tabby foundation of a smaller frame building that was likely a two-room slave quarter. An 1838 map shows

twenty-three buildings away from the main house, the quarters for the slaves who worked the land.[289]

James died in 1827 and left John in heavy debt. When John died in 1838, most of the property had been mortgaged to the Bank of Charleston. The bank ended up selling the land to William Eddings Baynard on December 17, 1845. In 1846, Baynard had a mausoleum constructed in the cemetery at the Zion Chapel of Ease, which was the first church built on the island in 1788. William Baynard was interred in his mausoleum in 1849, and his wife, Catherine, followed in 1854.

When war erupted between Great Britain and the United States in 1812, South Carolina was little affected, but the fear of attack was always present. In August 1813, two British warships, the HMS *Mosell* and *Calabri* (or *Calibre*), blockaded the entrance to Port Royal Sound. Sailors from these ships captured slaves from plantations on St. Helena and Pinckney Islands and destroyed a schooner owned by Charles Cotesworth Pinckney's sister. After a week, a hurricane forced the ships to depart and they never returned.[290]

On the eve of the Civil War, there were about twenty plantations on Hilton Head Island. Little did the owners of these plantations or their slaves know, but the onset of the Civil War would dramatically change their lives. In December 1860, South Carolina seceded from the United States, and in April 1861, Confederate artillery in Charleston attacked the steamer *Star of the West* and Fort Sumter in Charleston Harbor, which started the Civil War. Knowing Port Royal Sound would be a likely target, the Confederacy instructed General Beauregard to build two forts to guard the entrance to the sound. One fort was located on Hilton Head Island and was named Fort Walker after the Confederate secretary of war, L.P. Walker. The other fort was located across the sound at Bay Point and named Fort Beauregard in honor of the general. The Confederates had 1,430 men stationed on Hilton Head and were supported by a fleet of merchant steamers.

The Union's strategy early in the war was to blockade Southern ports in order to hinder ship movement, but that strategy changed to one of capturing key ports. A Federal committee in July 1861 had recommended to Lincoln three places to attack in South Carolina: Bull's Bay, St. Helena Island and Port Royal Sound.[291] It was eventually decided that Port Royal Sound would be attacked, and in the early fall of 1861, the navy and army began to assemble their forces.

On the morning of October 29, 1861, a fleet of seventy-seven Union ships carrying twenty thousand soldiers and five thousand sailors left Hampton Roads, Virginia, and headed for Port Royal Sound. The expedition was

15. Photograph of the ruins of the Baynard Plantation house, built sometime in the 1790s. *Photograph by the author.*

16. Photograph of the Baynard Mausoleum, built in 1846 at the Zion Chapel of Ease. *Photograph by the author.*

under the command of Flag Officer Samuel Francis DuPont and General Thomas W. Sherman. As they moved south, a hurricane scattered the fleet on November 1. Some ships sank, and others were lost and presumed sunk.

The fleet reassembled on November 4 just outside Port Royal Sound. After some bad weather, the ships were ready to strike, and on the morning of November 7, two lines of ships entered Port Royal Sound. They stayed in the middle of the channel and began firing on Fort Beauregard. The ships in the front then turned to head back out to sea and fired on Fort Walker as they passed Hilton Head. They kept up this circular pattern of attack until the Confederate forts stopped firing on them. When Union troops landed on Hilton Head, they found Fort Walker deserted, and the next day they found Fort Beauregard had also been deserted. The fleet of Confederate steamers was no match against the Union ships and only fired at them three times before retreating into Skull Creek, where they helped evacuate Confederate troops from Hilton Head Island.[292]

After securing the area, DuPont wrote, "This is a wonderful sheet of water—the navies of the world could ride here."[293] His quartermaster was also impressed and stated that "we are now in possession of the finest harbor in the South where the largest ships can enter and ride at anchor in safety."[294] It was decided that Hilton Head Island would be the headquarters for the Federal troops and navy. The Union used its base on Hilton Head to attack military objectives that included the burning of numerous homes in neighboring Bluffton, which was being used at the time by Confederates to observe Union ship and troop movements.

The Union transformed Hilton Head Island by constructing numerous support facilities such as barracks, hospitals and warehouses. The Federals renamed Fort Walker Fort Welles in honor of the Union's secretary of the navy and built Fort Mitchel to defend Skull Creek. In the channel, the Union erected a large dock approximately 1,277 feet in length and outfitted it with a rail line to aid in transporting supplies from the ships to the warehouses. In addition, the U.S. Quartermaster Corps office took over Seabrook Plantation on Skull Creek and used it as a place for supplying and repairing ships.[295]

During this time, slaves on Hilton Head Island and the surrounding areas began looking for refuge with the Union soldiers. As these numbers swelled, the Union was at a loss as to what to do with the refugees. Since they were not yet free, they were categorized as contraband. Major General Ormsby M. Mitchel, who was now the commander of the Department of the South and headquartered at Hilton Head, decided that a town should be built for them, as previous methods of housing had

proved inadequate. A town called Mitchelville, named after the general, was created on the property of Confederate general Thomas Fenwick Drayton. It was developed as a regular town with quarter-acre lots, roads and a town supervisor and councilmen elected by the residents. The inhabitants established laws and made education compulsory for children between the ages of six and fifteen.[296]

In 1864, Union troop levels on the island dropped, and it was decided that another fort needed to be constructed for the better defense of the island and the town of Mitchelville. The job of building this new fort went to the Thirty-Second U.S. Colored Infantry, which came from Camp William Penn in Philadelphia, Pennsylvania. The soldiers arrived in late April 1864, and by September, they had begun construction on Fort Howell, named after Brigadier General Joshua B. Howell.[297]

When the Civil War ended in 1865, the Union troops on Hilton Head remained. It was not until 1868 that military occupation ended. The population of the island dropped to just a few thousand people who continued to live there in isolation from the mainland. In the 1870s, some former owners of plantations on Hilton Head reclaimed their land after paying back taxes, but other land was owned by the U.S. government. The government sold some of it to speculators and some freemen.

William P. Clyde, who owned the Clyde Steamship Company in New York, purchased nine thousand acres of land on Hilton Head Island in the 1890s. He used the land as a hunting preserve, and by the 1900s, other groups such as the North Carolina Hunting Club had begun buying land in order to use it for hunting as well. That land and other land on the island, totaling twenty thousand acres, was bought by Landon K. Thorne and Alfred L. Loomis in 1930. During World War II, Marines were stationed at Camp McDougal and paved the first road on the island, which went from the ferry at the north end of the island to the Leamington Lighthouse, which was built in 1880.

In 1949, after the end of World War II, a group from Georgia purchased twenty thousand acres of land on the south end of the island, formed the Hilton Head Company and began logging the land. A few years later, in 1953, the state began operating a car ferry to the island, and in 1956, a swing bridge was constructed, opening up the island to more people. In that year, Joseph Frazer, who was an associate in the Hilton Head Company, sold his interest in the company to his son Charles E. Fraser, who was interested in turning the land at the south end of the island into a community. He called this new community Sea Pines Plantation, and in 1958, the first lot was sold.

Captain William Hilton and the Founding of Hilton Head Island

17. An 1861 map by George Woolworth Colton showing the Battle of Port Royal Sound. *Courtesy of the Library of Congress.*

18. An 1862 photograph of slaves of Confederate general Thomas F. Drayton on his Hilton Head Island plantation. *Courtesy of the Library of Congress.*

Captain William Hilton and the Founding of Hilton Head Island

At that time, an oceanfront lot sold for $5,350, but by 1962 they were selling for $9,600. In 1960, the first golf course, called the Ocean Course, was built on the island at Sea Pines. It was designed by George Cobb, who created the par-3 course at Augusta National Golf Club in 1959.

With a bridge now connecting Hilton Head Island to the mainland and the development of Sea Pines Plantation, more visitors began coming to the island. Before 1959, there was only one motel on the island, the Sea Crest Motel, which had only two rooms but expanded to eight in 1960. In 1959, the appropriately named William Hilton Inn opened up on South Forest Beach Drive. This fifty-six-room hotel operated until the 1990s before it was torn down to make way for the Marriott Grand Ocean Resort.[298]

Today, there are approximately 39,000 people who live on Hilton Head Island and around 2.67 million who visit the island each year.[299] Hilton Head Island emerged from a frontier area where few wanted to settle to a highly desirable location where first indigo and then cotton could be grown for great profits. After a period of decline following the Civil War, the island emerged once again, and from efforts that began in the late 1950s, Hilton Head Island became what it is today, one of the top vacation destinations in the United States. Through all of this, the name Hilton Head endured and is a reminder of the remarkable history of not only Captain Hilton but of the Port Royal Sound area and those who lived and died there as well.

Epilogue

In 1664, Captain William Hilton returned to Charlestown, Massachusetts, after exploring the Carolina coast. No evidence has emerged that he ever returned to South Carolina or took advantage of the one thousand acres of land he was granted there as a reward. He died on September 7, 1675, at the age of fifty-eight, leaving behind his wife, Mehitable, and nine out of his ten children. William's youngest child, Charles, was only two years old at the time of his father's death. What Captain Hilton died of is unknown, but since Charlestown was a port city and the residents of port cities were always vulnerable to diseases carried aboard ship, there was a chance that he fell victim to one of those ailments.

Despite the risk of disease, Hilton apparently did not leave a will behind, for one has yet to be found. There was, however, an inventory of his estate taken sixteen days after his death. It is revealing in that it indicates that he owned no ships at this time and the only land he possessed was a seventeen-acre wooded lot on the Mystic River. No house is mentioned, which means Hilton was either living in a house owned by one of his wife's relatives or was renting. The former might be the case; right before he was married in 1659, Hilton had sold his house and land in Charlestown.

As to be expected, the inventory lists "instruments for seaman's use" as well as a cow, books, a sword and staff along with household furniture. It also mentions "goods in the shop," which suggests Hilton had some sort of store attached to his house. The goods that were sold in his shop were not

Epilogue

listed, but he was probably selling a variety of items that were imported from England and the West Indies.

Of his seven sons, Hilton had only one who is known to have followed in his footsteps. Nowell Hilton, who was born in 1663, was the first child of Hilton's second marriage. Not much is known about him, but he was a crew member onboard the *Success* in 1683. In December of that year, the *Success* left Boston and sailed for Surinam, where it was loaded with sugar. Before the *Success* left Surinam, most of the crew had become ill and the ship's merchant had died. The *Success* then sailed to Amsterdam in Holland, where some of the crew, including Nowell Hilton, deserted. Since they had not been paid, they decided to sue the ship's master. They all eventually returned to the ship, and after stopping in Plymouth, England, the *Success* returned to Boston in 1685.[300]

Perhaps not fully recovered from the illness he contracted in Surinam, Nowell had his will drawn up in 1687. He appointed his "trusty and loving kinsman" Nathaniel Cutler his attorney.[301] In 1684, Hilton's widow Mehitable married John Cutler, whose wife, Ann, had recently died. Mehitable was no doubt already acquainted with John; Hilton's daughter Elizabeth, from his first marriage, had married John Cutler's son Timothy in 1673. In 1689, two years after he wrote his will, Nowell died at the age of twenty-six.

As to what happened to the *Adventure*, one of Hilton's ship masters, Pyam Blowers, ended up becoming part owner of the ketch along with his brother-in-law Andrew Belcher Jr. Belcher was the brother of Pyam's wife, Elizabeth, whom he had married in March 1668. In 1672, Pyam was referred to as Captain Blowers when he purchased a house and four and a half acres of land in Cambridge, Massachusetts, from Matthew Bridge, who was married to his wife's aunt.[302]

By 1672, Pyam appears to have been the captain of the *Adventure* as well as part owner. Sometime after 1668 Hilton probably sold the *Adventure* to Pyam and his brother-in-law. It may also be possible that Pyam—at some point during his association with Hilton—had become a part owner, and when Pyam was married in 1668 Hilton decided to sell his portion to Andrew Belcher Jr. Regardless, after selling the *Adventure*, Hilton appears to have not owned any more ships but instead probably operated a shop and focused on his family.

His first child with Mehitable was born about ten months after he left for his expedition along the Carolina coast. His next child, Edward, was born in 1666, and he and Mehitable had three more sons with a two- to three-

year gap in between their births. Hilton, who was in his late forties and early fifties when he had his children with Mehitable, might have decided that he had enough of life at sea and wanted to stay at home and continue growing his family.

On August 20, 1686, the *Adventure* is again mentioned when its owners, which now included John Keetch, petitioned the council in Boston for authorization to come into Boston Harbor and take on wood and water. They also requested "waiters" be brought on board to inspect the ship to see that nothing was being smuggled in:

> *Upon the Petition of Andrew Belcher and John Keetch Merchants, and part owners of the Ketch* Adventure *Pyam Blowers Master bound from New-foundland, being loaden with fish and other Merchandize humbly praying Licence to touch at Boston to Wood and Water, & desireing that Waiters may be putt on board when she arrives at their charge, that she may thence proceed on her voyage to the Maderas.*[303]

It seems they wanted the *Adventure* to be quickly inspected and take on wood and water before it proceeded across the Atlantic Ocean to the Madeira Islands off the coast of Portugal with a cargo of fish and other merchandise.

The ultimate fate of the *Adventure* is unknown, but the vessel seems to have continued to make voyages along the coast and into the Atlantic, trading in distant and not so distant lands. Its use by Captain Hilton in exploring the Carolina coast ushered in an era of colonial expansion by the English that transformed South Carolina into one of the wealthiest colonies in British America by the onset of the Revolutionary War.

Notes

Introduction

1. William Hilton, Anthony Long and Peter Fabian, *A Relation of a Discovery Lately Made on the Coast of Florida* (London, Printed by J.C. for Simon Miller at the Star neer the West-end of St. Pauls, 1664), reprinted in *Narratives of Early Carolina 1650–1708*, ed. Alexander S. Salley Jr. (New York: Charles Scribner's Sons, 1911), 45.

Chapter 1

2. Robert Charles Anderson, *The Great Migration Begins Immigrants to New England 1620–1633*, vol. 2 (Boston: Great Migration Study Project, New England Historic Genealogical Society, 1995).
3. Hannah Newton, "The Dying Child in Seventeenth-Century England," *Pediatrics* 136, no. 2 (August 2015): 218–220. https://www.ncbi.nlm.nih.gov/pmc/articles/PMC4568305/#R5.
4. Anderson, *Great Migration Begins*, 2:947.
5. Plimoth Plantation, "Who Were the Pilgrims?," https://www.plimoth.org/learn/just-kids/homework-help/who-were-pilgrims.
6. Margaret Pickett and Dwayne Pickett, *The European Struggle to Settle North America: Colonizing Attempts by England, France and Spain, 1521–1608* (Jefferson, NC: McFarland, 2011).

7. Peggy M. Baker, "The Plymouth Colony Patent: Setting the Stage," Pilgrim Society & Pilgrim Hall Museum, 2007, http://www.pilgrimhallmuseum.org/pdf/The_Plymouth_Colony_Patent.pdf.
8. William Bradford, *Of Plymouth Plantation, 1620–1647* (New York: Modern Library, 1967) 59.
9. Ibid.
10. Captain John Smith, *New England's Trials*, expanded edition, 1622, reprinted in *The Complete Works of Captain John Smith*, ed. Philip L. Barbour (Chapel Hill: University of North Carolina Press, published for the Institute of Early American History and Culture, Williamsburg, Virginia, 2011), 430–31.
11. Anderson, *Great Migration Begins*, 2:953.
12. The 1623 Division of Land, MayflowerHistory.com, 2009, https://static1.squarespace.com/static/50a02efce4b046b42952af27/t/50a87303e4b08d1f2ced352a/1353216771962/DivisionOfLand1623.pdf.
13. Dr. Jeremy Dupertuis Bangs, "A Level Look at Land Allotments, 1623," *Mayflower Quarterly* 72 (March 2006): 38–39.
14. William Hubbard, *General History of New England: From the Discovery to MDCLXXX* (Boston: C.C. Little and J. Brown, 1848).
15. John Scales, *History of Dover, New Hampshire*, vol. 1, *Containing Historical, Genealogical and Industrial Data of its Early Settlers, Their Struggles and Triumphs.* (Manchester, NH: Printed by authority of the City Councils, 1923), 24. In a 1660 petition, Captain William Hilton stated that his family and Edward were in Piscataqua shortly after their arrival in 1623.
16. Richard C. Simmons, *The American Colonies: From Settlement to Independence* (New York: W.W. Norton & Company, 1981).
17. Scales, *History of Dover*, vol. 1:23.
18. Scott Auden and Alan Taylor, *Voices from Colonial New Hampshire 1603–1776* (Washington, D.C.: National Geographic Society, 2007).
19. Scales, *History of Dover*, vol. 1:23.
20. Auden and Taylor, *Voices from Colonial New Hampshire*.
21. Scales, *History of Dover*, 1:24.
22. John Winthrop, *Gov. John Winthrop Papers* [hereafter *Winthrop Papers*], vols. 1–5, *1557–1649* (Boston: Massachusetts Historical Society, 1929), 3:449.
23. Anderson, *Great Migration Begins*, 2:951.
24. Ibid., 956.
25. Ibid., 952.
26. James Edward Greenleaf, *Genealogy of the Greenleaf Family* (Boston: Frank Wood, 1896).

27. Ibid.
28. "Raising Children in the Early 17th Century: Demographics," a collaboration between Plimoth Plantation and the New England Historic Genealogical Society supported by the Institute for Museum and Library Services, https://www.plimoth.org/sites/default/files/media/pdf/edmaterials_demographics.pdf.
29. Greenleaf, *Genealogy*, 72.
30. Anderson, *Great Migration Begins*, 2:956.
31. Ibid.
32. Hubbard, *General History*, 554.
33. *A Report of the Records Commissioners Containing Charlestown Land Records, 1638–1802*, 2nd ed. (Boston: Rockwell and Churchill City Printers, 1883).
34. Anderson, *Great Migration Begins*, 2:1,342–46.
35. Ibid.
36. Ibid.

Chapter 2

37. Richard Ligon, *A True and Exact History of the Island of Barbados*, ed. Karen Ordahl Kupperman (Indianapolis: Hackett Publishing, 2011).
38. David Watts, *The West Indies: Patterns of Development, Culture and Environmental Change Since 1492* (Cambridge, UK: Cambridge University Press, 1987).
39. Sir Henry Colt, "Breife Discription of the Ilande of Barbados," in *Colonizing Expeditions to the West Indies and Guiana*, ed. Vincent T. Harlow, Halkluyt Society Works vol. 56, no. 2 (Millwood, NY: Kraus International Publishing, 1988).
40. Henry Winthrop to Emmanuel Downing, August 22, 1627, *Winthrop Papers*, 1:356–57.
41. Henry Winthrop to John Winthrop, October 15 1627, *Winthrop Papers*, 1:361–62.
42. John Winthrop to Henry Winthrop, January 28, 1628, *Winthrop Papers*, 2:66–69.
43. Ligon, *True and Exact History*.
44. Nicholas Foster, *A Briefe Relation of the Late Horrid Rebellion Acted in the Island of Barbados in the West Indies* (Originally published 1650. London: Reprinted on behalf of W.R. Redman by Spottiswoode, Ballantyne, 1927).
45. Matthew Parker, *The Sugar Barons: Family, Corruption, Empire, and War in the West Indies* (New York: Walker Books, 2012).

46. Ibid., 19.
47. Ibid., 20.
48. Ibid., 45.
49. Ibid.
50. Ibid.
51. Richard Vine to John Winthrop, July 19, 1647, *Winthrop Papers*, 1:361–62.
52. Sir George Downing to John Winthrop, August 26, 1645, *Winthrop Papers*, 5:43.
53. Daniel Vickers, *Farmers & Fishermen: Two Centuries of Work in Essex County, Massachusetts, 1630–1850* (Chapel Hill: University of North Carolina Press, 1994), 99.
54. Thomas Morton, *The New English Canaan of Thomas Morton*, ed. Charles Frances Adams Jr. (Boston: Prince Society, 1883), 222.
55. Beauchamp Plantagenet, *Description of the Province of New Albion*, originally printed in 1648 (Washington, D.C.: P. Force, 1837), 4.
56. James K. Hosmer, ed. *Winthrop's Journal "History of New England" 1630–1649*, vol. 2 (New York: Scribner, 1908), 327.
57. Ibid., 31.
58. Ibid., 260.
59. Ibid., 227.
60. Parker, *Sugar Barons*.
61. Sir George Downing to John Winthrop, August 26, 1645, *Winthrop Papers*, 5:43.
62. John Povey, *An Estimate of the Barbados and of the Now Inhabitants There*, British Library, Egerton MS 2395 fol., 625.
63. Parker, *Sugar Barons*, 59.
64. Ibid.
65. Samuel Hartlib, *Ephemerides*, Part 2 Ref. 28/2/54A, Hartlib Papers 2nd ed., 1653, Humanities Research Institute, University of Sheffield, UK.
66. William Bullock, *Virginia Impartially Examined* (London: John Hammond, 1649), 14.
67. Ibid.
68. Parker, *Sugar Barons*.
69. Ligon, *True and Exact History*, 93.
70. Ibid., 94.
71. Colt, "Breife Discription," 44–45.
72. Ligon, *True and Exact History*, 106.
73. Sir George Downing to John Winthrop, August 26, 1645, *Winthrop Papers*, 6:539.

74. Ligon, *True and Exact History*.
75. Ibid., 97.
76. Anderson, *Great Migration Begins*, 2:22.
77. Almon Wheeler Lauber, *Indian Slavery in Colonial Times Within the Present Limits of the United States* (Williamstown, MA: Corner House Publishers, 1979), 123.
78. Francis Newton Thorpe, *The Federal and State Constitutions, Colonial Charters, and Other Organic Laws of the States, Territories, and Colonies Now or Heretofore Forming the United States of America Compiled and Edited Under the Act of Congress of June 30, 1906* (Washington, D.C.: Government Printing Office, 1909).

Chapter 3

79. Edson I. Carr, *The Carr Family Records. Embacing [sic] the Record of the First Families Who Settled in America and Their Descendants, with Many Branches Who Came to This Country at a Later Date* (Rockton, IL: Herald Printing House, 1894).
80. *An Historic Guide to Cambridge* (Cambridge, MA: Hannah Winthrop Chapter National Society, Daughters of the American Revolution, 1907), 93. Captain Hilton's shipmaster Pyam Blowers and Pyam's brother-in-law would end up co-owning "the ketch Adventure."
81. Frederic C. Lane, "Tonnages, Medieval and Modern," *Economic History Review* 17, no. 2 (1964): 213–33.
82. Thomas Modyford and Sir Peter Colleton, "Proposal by Thomas Modyford and Peter Colleton concerning the settlement of Carolina by inhabitants of Barbados, August 10, 1663," in *Colonial and State Records of North Carolina*, vol. 1 (Raleigh, NC: P.M. Hale, printer to the state, 1886), 39–42.
83. Ralph Davis, *The Rise of the English Shipping Industry in the Seventeenth and Eighteenth Centuries* (London: National Maritime Museum, 1962), 68.
84. John Robinson and George Francis Dow, *Sailing Ships of New England: 1607–1907* (Salem: Massachusetts Marine Research Society, 1922).
85. Ibid., 23.
86. Sir John Henry Lefroy, *Memorials of the Discovery and Early Settlement of the Bermudas or Somers Islands, 1515–1687* (London: Longmans, Green and Company, 1877).
87. Louise Hall, "New Englanders at Sea: Cape Fear Before the Royal Charter of 24 March 1662/3," *New England Historical and Genealogical Register* 124 (April

1970): 90. Louise Hall states, "[I]nfrequent references to Captain Hilton in Surinam or London, Barbados or Carolina…support the impression of a busy life at sea." Unfortunately, she does not cite where she got this information.
88. Middlesex County, MA, Probate File Papers, 1648–1871, Page 11558:2, https://www.americanancestors.org/databases/middlesex-county-ma-probate-file-papers-1648-1871/image?pageName=11558:2&volumeId=14462&rId=38289031.
89. George Francis Dow, *Every Day Life in the Massachusetts Bay Colony* (New York: Dover Publications, 1988), 270.
90. John James Currier, *History of Newbury, Massachusetts, 1635–1902* (Boston: Damrell & Upham, 1902).
91. *Records of Massachusetts*, vol 4, part 2, 1661–1674 (Boston: from the Press of William White, 1854).
92. Lynn Betlock, "New England's Great Migration," *New England Ancestors* 4, no. 2 (2003): 22–24.
93. Hall, "New Englanders at Sea."
94. Pickett and Pickett, *European Struggle*.
95. Hall, "New Englanders at Sea," 105.
96. Ibid.
97. Ibid., 105–6.
98. Ibid., 106.
99. Collections of the Massachusetts Historical Society, series 3, vol. 1 (Boston: reprinted Charles C. Little and James Brown, 1846), 56.
100. Ibid., 25.
101. Modyford and Colleton, "Proposal," 39–42.
102. John Lawson, *A New Voyage to Carolina* (Chapel Hill: University of North Carolina Press, 1984).
103. Hilton, Long and Fabian, *Relation of a Discovery*, 53.
104. Charter of Carolina, March 24, 1663, in the *Colonial Records of North Carolina*, vol. 1, *1662–1712*, ed. William L. Saunders (Raleigh, NC: P.M. Hale, 1886), 20–33.
105. CM Fraser, *A History of Anthony Bek, Bishop of Durham from 1283–1311* (Oxford, UK: Clarendon Press), 1957.
106. Charter of Carolina.
107. "The Colleton Family in South Carolina," *South Carolina Historical and Genealogical Magazine* 1, no. 4 (October 1900): 325–41.
108. Thomas Modyford and Sir Peter Colleton, "Proposealls of Several Gentlemen of Barbadoes, August 12, 1663," in *The Shaftsbury Papers*, first compiled 1897 (South Carolina Historical Society, 2010), 11.

109. Ibid., 10.
110. Ibid.

Chapter 4

111. A Captain Anthony Long was a witness to the will of Thomas Sandiford in Barbados, which was signed in 1661. Joanne McRee Sanders, ed., *Barbados Records—Wills and Administrations*, vol. 1, *1639–1680* (Baltimore, MD: Clearfield Publishing, 2011), 317
112. Hilton, Long and Fabian, *Relation of a Discovery*, 39.
113. "How Fast Is the Gulf Stream?," National Ocean Service National Oceanographic and Atmospheric Administration, https://oceanservice.noaa.gov/facts/gulfstreamspeed.html. In *Relation of a Discovery*, Hilton recorded that they traveled 550 leagues from Barbados to the present-day coast of South Carolina, which is approximately 1,900 miles.
114. Pickett and Pickett, *European Struggle*.
115. Hilton, Long and Fabian, *Relation of a Discovery*, 45.
116. Olivia Isil, edited and expanded by Lebame Houston and Wynne Dough, "Navigation and Related Instruments in 16th-Century England," National Park Service, last modified April 14, 2015, https://www.nps.gov/fora/learn/education/navigation-and-related-instruments-in-16th-century-england.htm.
117. Hilton, Long and Fabian, *Relation of a Discovery*, 37.
118. In 1526, a judge from Hispaniola named Lucas Vazquez de Ayllon tried to start a settlement in South Carolina that failed after only a few months. During this attempt at colonization, a group was sent out to find a better location for the settlement. That is when they sailed into Port Royal Sound and were so impressed with it that they decided to name the whole area Santa Elena after Saint Helena, whose feast day it was when they made the discovery. Paul E. Hoffman, *A New Andalucia and a Way to the Orient: The American Southeast During the Sixteenth Century* (Baton Rouge: Louisiana State University Press, 2004).
119. Hilton, Long and Fabian, *Relation of a Discovery*, 38.
120. Allen Mordica, "The Lead Line—Construction and Use," The Navy & Marine Living History Association, https://www.navyandmarine.org/planspatterns/soundingline.htm.
121. Hilton, Long and Fabian, *Relation of a Discovery*, 39.
122. Ibid.
123. Ibid. Grandy is what the North Edisto River was called when Hilton was there.

124. Eugene Lyon, "Richer Than We Thought: The Material Culture of Sixteenth-Century St. Augustine," *El Escribano*, the St. Augustine Journal of History (1992): 83.
125. Eugene Lyon, "Santa Elena: A Brief History of the Colony, 1566–1587," University of South Carolina Scholar Commons Research Manuscript Series, Institute of Archaeology and Anthropology, South Carolina, 1984.
126. Hilton, Long and Fabian, *Relation of a Discovery*, 39.
127. Ibid., 40.
128. Ibid.
129. Ibid.
130. John Reed Swanton, *The Indian Tribes of North America*, Smithsonian Institution Bureau of American Ethnology Bulletin 145 (Washington, D.C.: Government Printing Office, 1952).
131. Thomas Ashe, *Carolina, or a Description of the Present State of that Country* (London: T.A. Gent, 1682).
132. Gene Waddell, *Indians of the South Carolina Lowcountry, 1562–1751* (Columbia: University of South Carolina Press, 1980).
133. Hilton, Long and Fabian, *Relation of a Discovery*, 41.
134. Ibid.
135. DePratter, Chester B., Stanley South and James B. Leg, "Charlesfort Discovered!," University of South Carolina Scholar Commons Research Manuscript Series, Institute of Archaeology and Anthropology, South Carolina, 1996.
136. Hilton, Long and Fabian, *Relation of a Discovery*, 54–55.
137. Ibid., 42.
138. Ibid., 50.
139. Ibid., 55.
140. Ibid., 42.
141. Ibid., 56–57.
142. Ibid., 43.
143. Ibid., 42.
144. Ibid., 44.
145. Ibid.
146. Ibid.
147. Ibid., 45.
148. Carville Earle, "Environment, Disease and Mortality in Early Virginia," *Journal of Historical Geography* 5, no. 4 (1979): 365–90.
149. Hilton, Long and Fabian, *Relation of a Discovery*, 45.

150. Ibid.
151. Ibid.
152. Ibid., 48.
153. Ibid., 49.
154. Ibid.
155. Ibid., 50.
156. Ibid.
157. Ibid., 50–51.
158. Ibid., 51.
159. Ibid.
160. Ibid., 52.
161. Ibid.
162. Ibid.
163. Ibid.

Chapter 5

164. Charles II, "An Act for preventing the frequent Abuses in printing seditious treasonable and unlicensed Bookes and Pamphlets and for regulating of Printing and Printing Presses," 1662. In *Statutes of the Realm*, vol., *1628–80*, ed. John Raithby (N.p.: Great Britain Record Commission, 1819), 428–35, British History Online, accessed August 3, 2018, http://www.british-history.ac.uk/statutes-realm/vol5/pp428-435.
165. Ibid.
166. Ibid.
167. Charles II, Domestic State Papers, vol. 81, no. 73, 73 i., ii., iii, https://babel.hathitrust.org/cgi/pt?q1=moon;id=msu.31293027026883;view=plaintext;seq=309;start=1;sz=10;page=root;num=297;size=100;orient=0.
168. Frank Arthur Mumby, *Publishing and Bookselling*, part 1, *From the Earliest Times to 1870*, 5th ed. (London, Jonathan Cape, 1974).
169. Hilton, Long and Fabian, *Relation of a Discovery*.
170. Ibid., 57.
171. Ibid.
172. Ibid., 58.
173. Ibid., 60.
174. Robert Horne, "A Brief Description of the Province of Carolina, 1666," in *Narratives of Early Carolina 1650–1708*, ed. Alexander S. Salley Jr. (New York: Charles Scribner's Sons, 1911), 71.

175. Ibid., 72.
176. William Berkeley, *A Discourse and View of Virginia* (London, 1663).
177. Lords Proprietors of Carolina Commission to Sir John Yeamans, January 11, 1664. In Colonial and State Records of North Carolina, vol. 1 (Raleigh, NC: P.M. Hale, printer to the state, 1886), 97–98.
178. Charles H. Lesser, "Yeamans, Sir John 1611—August 14, 1674," *South Carolina Encyclopedia*, http://www.scencyclopedia.org/sce/entries/yeamans-sir-john; St. Nicholas Abbey, "Owners' History," http://www.stnicholasabbey.com/The-Plantation/Owners-History.
179. Robert Sanford, "A Relation of a Voyage on the Coast of the Province of Carolina, 1666," in *Narratives of Early Carolina 1650–1708*, ed. Alexander S. Salley Jr. (New York: Charles Scribner's Sons, 1911), 83–84.
180. Horne, "Brief Description," 67.
181. J. Rickard, "Second Anglo-Dutch War (1665–1667)," History of War, December 12, 2000, http://www.historyofwar.org/articles/wars_anglodutch2.html.
182. John S. Morrill, "Great Plague of London: Epidemic, London, England, United Kingdom 1665–1666," *Encyclopedia Britannica*, https://www.britannica.com/event/Great-Plague-of-London.
183. Ben Johnson, "The Great Fire of London," Historic UK, https://www.historic-uk.com/HistoryUK/HistoryofEngland/The-Great-Fire-of-London.
184. Sanford, "Relation of a Voyage," 85.
185. Ibid.
186. Ibid., 88.
187. Ibid., 90.
188. Ibid., 90–91.
189. Ibid., 91.
190. Ibid., 98.
191. Ibid., 100–101.
192. Ibid., 101.
193. Ibid., 103.
194. Ibid.
195. Ibid., 104–5.
196. Ibid., 105.
197. Alexander S. Salley, ed., *Narratives of Early Carolina 1650–1708* (New York: Charles Scribner's Sons, 1911), 127.
198. Patrick Connolly, "J. John Locke (1632–1704)," Internet Encyclopedia of Philosophy, https://www.iep.utm.edu/locke.

199. Thorpe, *Federal and State Constitutions*.
200. Ibid.
201. Ibid.
202. Ibid.
203. Joseph West to Lord Ashley, August 10, 1669, in *Shaftsbury Papers*.
204. Romola Anderson and R.C. Anderson, *A Short History of the Sailing Ship* (Mineola, NY: Dover Publications, 2003).
205. Mr. Carteret's relations, in *Shaftsbury Papers*, 166.
206. Stephen Bull to Lord Ashley, Albemarle Poynt, September 12, 1670. Collections of the South-Carolina Historical Society, vol. 5 (Charleston, 1897), 194.
207. Mr. Carteret's relations, in *Shaftsbury Papers*, 167.
208. Ibid.
209. Ibid., 168.
210. Ibid.
211. John E. Worth, *The Struggle for the Georgia Coast* (Tuscaloosa: University of Alabama Press, 2007).
212. Mr. Mathews's relations, in *Shaftsbury Papers*, 169.
213. Ibid.
214. Joseph West to Lord Ashley, June 27, 1670, in *Shaftsbury Papers*, 174.
215. William Owens to Lord Ashley, September 15, 1670, in *Shaftsbury Papers*, 199.
216. Antonio de Arredondo, *Arredondo's Historical Proof of Spain's Title to Georgia: A Contribution to the History of One of the Spanish Borderlands* (Berkeley: University of California Press, 1925).

Chapter 6

217. Albert C. Goodyear III, "The Search for the Earliest Humans in the Land Recently Called South Carolina," in *Archaeology in South Carolina: Exploring the Hidden Heritage of the Palmetto State*, ed. Adam King (Columbia: University of South Carolina Press, 2016).
218. Matthew C. Sanger, "The Sea Pines Shell Ring," Sea Pines Resort, https://www.seapines.com/recreation/activities-tours/sea-pines-shell-ring.aspx.
219. "Native American Time Periods and Artifact Sequence," South Carolina Department of Archives and History, https://shpo.sc.gov/historic-preservation/resources/native-american-heritage/native-american-time-periods-and-artifact.

220. Samuel Wilson, "An Account of the Province of Carolina, in America," in *Narratives of Early Carolina 1650–1708*, 174.
221. Lawrence S. Rowland, Alexander Moore and George C. Rogers Jr., *The History of Beaufort County, South Carolina: 1514–1861* (Columbia: University of South Carolina Press, 1996).
222. John Broad, "Cattle Plague in 18th Century England," *British Agricultural History Review* 31, no. 2 (1983): 104–15.
223. Robert M. Weir, *Colonial South Carolina: A History* (Columbia: University of South Carolina Press, 1997), 143.
224. Henry Woodward, "A Faithful Relation of My Westoe Voiage, December 31, 1674," in *Narratives of Early Carolina 1650–1708*, 130.
225. Ibid., 132.
226. Rowland, Moore and Rogers, *History of Beaufort County*.
227. "The Inventory of Historic Battlefields—Battle of Bothwell Bridge," Historic Scotland, http://data.historic-scotland.gov.uk/data/docs/battlefields/bothwellbridge_summary.pdf.
228. John Crafford, *A New and Most Exact Account of the Fertiles and Famous Colony of Carolina (On the Continent of America)* (Dublin: Nathan Tarrant, 1683).
229. Worth, *Struggle for the Georgia Coast*.
230. Francisco de Barbosa, Census of Guale and Mocama, June 7, 1683. In Marquez Cabrera, Don Juan, letter to the Crown, June 28, 1683, General Archives of the Indies, Seville, 54-5-12/9.
231. Luis Rafael Arana, "The Alonso Solana Map of Florida," *Florida Historical Quarterly* 17, no. 3 (January 1964): 258–66.
232. Rowland, Moore and Rogers, *History of Beaufort County*, 72.
233. Barbara J. Olexer, *The Enslavement of the American Indian in Colonial Times* (Columbia, MD: Joyous Publishing, 2005), 108.
234. Rowland, Moore and Rogers, *History of Beaufort County*, 82.
235. Henry A.M. Smith, "The Baronies of South Carolina," *South Carolina Historical and Genealogical Magazine* 15, no. 1 (January 1914).
236. A.S. Salley Jr., ed, *The South Carolina Historical and Genealogical Magazine* 15, no. 1 (January 1914): 165.
237. Rowland, Moore and Rogers, *History of Beaufort County*, 89.
238. Alan Calmes, "The Southern Coastal Frontier of South Carolina at Port Royal, Based on the Gascoigne Map and Survey Journals of 1728–1731," *Institute of Archeology and Anthropology Notebook* 3, no 3 (1973): 73–78.
239. Thomas Cooper, David James McCord and A.S. Johnston, *The Statutes at Large of South Carolina: Acts from 1682 to 1716* (Columbia, SC: Republican Print Company, 1837).

240. William L. McDowell Jr., ed., *Journals of the Commissioners of Indian Trade*, September 20, 1710–August 29, 1718, South Carolina Department of Archives and History, Columbia.
241. Francis Yonge, *A View of the Trade of South Carolina with Proposals Humbly Offer'd for Improving the Same* (London, 1722).
242. Governor Francisco de Corcoles y Martinez, letter dated January 25, 1716, regarding the arrival of four caciques in St. Augustine. Selected documents from Archivo General de Indias, Santo Domingo 843, relative to the Yamassee War, preliminary translation by John E. Worth, March 2007. Quote reprinted in Alex Sweeney and Eric Poplin, "The Yamasee Indians of Early Carolina," in *Archaeology in South Carolina*, ed. Adam King (Columbia: University of South Carolina Press, 2016).
243. Ibid.
244. "An Account of Missionaries Sent to South Carolina, the Places to Which They Were Appointed, Their Labours and Success, etc.," in *Early History of the Creek Indians and Their Neighbors*, John Reed Swanton, Smithsonian Institution Bureau of American Ethnology Bulletin 73 (Washington, D.C.: Government Printing Office, 1922), 97.
245. "An Account of the Breaking Out of the Yamassee War, in South Carolina, Extracted from the Boston News, of the 13th of June, 1715," in *Early History of the Creek Indians and Their Neighbors*, John Reed Swanton, Smithsonian Institution Bureau of American Ethnology Bulletin 73 (Washington, D.C.: Government Printing Office, 1922), 98.
246. Katharine M. Jones, ed., *Port Royal Under Six Flags* (New York: Bobbs-Merril Company, 1960).
247. Arthur Middleton, letter to Duke of Newcastle, June 13, 1728, in *Calendar of State Papers Colonial, America and West Indies*, vol. 36, *1728–1729*, ed. Cecil Headlam and Arthur Percival Newton (London, 1937), 129–43, British History Online, accessed August 26, 2018, http://www.british-history.ac.uk/cal-state-papers/colonial/america-west-indies/vol36/pp129-143.
248. Ibid.
249. Ibid.
250. Rowland, Moore and Rogers, *History of Beaufort County*, 1067.
251. Arthur Middleton, letter to Duke of Newcastle, June 13, 1728, in *Calendar of State Papers Colonial, America and West Indies*, vol. 36, *1728–1729*, ed. Cecil Headlam and Arthur Percival Newton (London, 1937), 129–43, British History Online, accessed August 26, 2018, http://www.british-history.ac.uk/cal-state-papers/colonial/america-west-indies/vol36/pp129-143.
252. *South Carolina Historical Magazine* 68, no. 2 (April 1967).

253. Robert Peeples, "An Index to Hilton Head Island Names (Before the Contemporary Development)," manuscript on file at the Heritage Library, Hilton Head Island, South Carolina.

Chapter 7

254. *South Carolina Gazette*, February 12, 1763.
255. Merrill G. Christophersen, *Biography of an Island: General C.C. Pinckney's Sea Island Plantation* (Fennimore, WI: Westburg Associates Publishers, 1976).
256. *South Carolina Gazette*, April 26, 1739.
257. *South Carolina Gazette*, November 13, 1740.
258. Weir, *Colonial South Carolina*.
259. *American Husbandry; Containing an Account of the Soil, Climate, Production and Agriculture of the British Colonies in North-America and the West-Indies*, vol. 1 (London: Printed for J. BEW, in Paternoster-Row, 1775), by an American in two volumes.
260. Weir, *Colonial South Carolina*.
261. Margaret Pickett, *Eliza Lucas Pinckney: Colonial Plantation Manager and Mother of American Patriots 1722–1793* (Jefferson, NC: McFarland, 2016).
262. Inventory of Nathaniel Barnwell appraised January 7, 1778. Inventories, CC (1776–1778), 308, South Carolina Department of Archives and History, Columbia.
263. Inventory of John Chaplin appraised October 3, 1776, Inventories, CC (1776–1778), 110–12, South Carolina Department of Archives and History, Columbia.
264. *South Carolina Gazette*, April 13, 1769.
265. *South Carolina Gazette and Country Journal*, October 17, 1769.
266. *South Carolina and American General Gazette*, February 6, 1769.
267. *South Carolina Gazette*, January 18, 1748.
268. *South Carolina Gazette and Country Journal*, April 26, 1768.
269. *South Carolina and American General Gazette*, July 22, 1771.
270. *South Carolina Gazette and Country Journal*, March 9, 1773.
271. Rowland, Moore and Rogers, *History of Beaufort County*.
272. *South Carolina Gazette*, September 28, 1765.
273. Rowland, Moore and Rogers, *History of Beaufort County*, 185, 206; Lynn Harris, "Shipyards and European Shipbuilders in South Carolina (Late 1600s to 1800)," University of South Carolina Scholar Commons Publications Maritime Research Division, 1999.

274. *South Carolina Gazette*, January 25, 1772.
275. *South Carolina Gazette and Country Journal*, December 24, 1771.
276. Rowland, Moore and Rogers, *History of Beaufort County*, 203–4.
277. Ibid.
278. *South Carolina and American General Gazette*, February 3, 1779.
279. Rowland, Moore and Rogers, *History of Beaufort County*, 1996.
280. *London Gazette*, from Tuesday, December 2, to Saturday, December 25, 1779.
281. Virginia C. Holmgren, *Hilton Head: A Sea Island Chronicle* (Hilton Head Island, SC: Hilton Head Island Publishing, 1959); Margaret Greer, *The Sands of Times: A History of Hilton Head Island* (Hilton Head Island, SC: SouthArt Inc., 1989).
282. Holmgren, *Hilton Head*.
283. *Royal Gazette* (Charles Towne, SC), January 20, 1782.
284. George Howe, *History of the Presbyterian Church in South Carolina* (Columbia, SC: Duffie & Chapman, 1870).
285. Natalie Adams and Michael Trinkley, "Archaeological Testing at the Stoney/Baynard Plantation, Hilton Head Island, Beaufort County, South Carolina," Chicora Foundation Research Series 28, October 1991.
286. Rowland, Moore and Rogers, *History of Beaufort County*, Page 281.
287. Ibid., 348.
288. Ramon Jackson, "Gullah Cultural Traditions: Origins and Practices," Charleston's African-American Heritage, http://www.africanamericancharleston.com/gullah.html.
289. Adams and Trinkley, "Archaeological Testing."
290. Rowland, Moore and Rogers, *History of Beaufort County*, 289.
291. Jones, *Port Royal*, 209.
292. Ibid., 215; Daniel Ammen, *Battles and Leaders of the Civil War: Being for the Most Part Contributions by Union and Confederate Officers: Based upon "The Century War Series,"* vol. 8 (New York, 1887–88), 674.
293. James M. Merrill, *DuPont, the Making of an Admiral: A Biography of Samuel Francis DuPont* (New York: Dodd, Mead, 1986).
294. Robert M. Scott, *War of the Rebellion: Official Records of the Union and Confederate Armies*, series 1, vol. 6 (1882), 186.
295. Jones, *Port Royal Under Six Flags*, 233.
296. Michael B. Trinkley and Debi Hacker, "The Archaeological Manifestations of the 'Port Royal Experiment' at Mitchelville, Hilton Head Island, (Beaufort County), South Carolina," Chicora Foundation Inc. Research Contribution 14, Columbia, South Carolina, 1987.

297. National Register of Historic Places Registration Form for Fort Howell, prepared by Martha H. Hocutt, J. Tracy Power, PhD, and James B. Legg, April 27, 2011.
298. Natalie Hefter, Images of America: *Hilton Head Island* (Charleston, SC: Arcadia Publishing, 1998).
299. Hilton Head Island-Bluffton Chamber of Commerce, https://www.hiltonheadchamber.org/business-resources/press-and-media/fast-facts.

Epilogue

300. *Genealogical Magazine* 3 (December 1915–September 1916): 90–92.
301. John T. Assam, *Notes and Queries Concerning the Hassam and Hilton Families* (Boston: David Clapp and Son, 1880), 3.
302. *Historic Guide to Cambridge*, 93.
303. *Council Records of Massachusetts Under the Administration of President Joseph Dudley*, Massachusetts Historical Society, January 1, 1900, 267, Harvard College Library.

INDEX

A

Adventure 35, 36, 37, 39, 40, 44, 45, 49, 50, 53, 56, 58, 59, 61, 64, 118, 119
Alush 51, 61, 77
Arguelles, Alonso 53, 54, 55
Ashley River 76, 78

B

Barbados
 attacked 1665 68
 colonists try to settle Cape Fear 65
 first settled 26
 Hilton sailed from 44
 Hilton set sail for 61
 indentured servants 32
 kidnapped Indians taken to 69, 71
 land prices 28
 location 25
 origin of name 25
 richest English colony 28
 slaves 30, 34
 sugar production 27
 trade with 14, 29, 35, 37, 82, 83
 yellow fever 31
Barnwell, John 93, 94
Bayley, John 87, 96, 105, 109
Baynard, William 111
Beaufort, South Carolina 85, 89, 90, 92, 93, 97, 98, 102, 104, 106, 107, 110
Beauregard, P.G.T. 111
Berkeley, William 43, 66
Bermuda 15, 25, 35, 37, 74, 75
Bloody Point 94, 105, 106
Blowers, Pyam 45, 64, 118, 119
Boston, Massachusetts 19, 21, 30, 37, 118, 119
Brazil 27, 28
Bridgetown, Barbados 30, 61

C

Calibogue Sound 72, 108
Cape Fear 16, 39, 40, 41, 42, 44, 54, 58, 61, 65, 67, 68, 69, 72, 73

INDEX

Cape Fear River 40, 61, 67
Carolina 74, 75, 78
Carr, George 35, 36, 37
cattle 24, 29, 42, 58, 82, 83, 87, 91, 92, 102, 106
Charlesfort 53
Charleston, South Carolina 51, 75, 76, 78, 104, 106, 107, 108, 109, 110, 111
Charles Towne, Cape Fear 65
Charles Towne, South Carolina 76, 81, 84, 85, 86, 87, 89, 92, 98, 99
Charlestown, Massachusetts 13, 23, 24, 29, 38, 39, 40, 42, 117
Church of England 16, 62, 84, 104
Civil War 81, 111, 114, 116
Clarendon County 65, 67
Clyde, William P. 114
Colleton, John 43, 44
Colleton, Peter 44, 65
Combahee River 49, 53, 56, 75, 87, 98
Cooper, Anthony Ashley 73
cotton 26, 27, 29, 30, 31, 109, 116
Craven County 67
Creek Indians 91, 92, 94
Cromwell, Oliver 44, 84
Cusabo Indians 51, 93

D

Daufuskie Island 94, 105, 106, 108, 109
Davant, Charles 108
Dawson, Alexander 94
deerskins 83
Downing, George 28, 30
Drax, James 27, 28
DuPont, Samuel Francis 113

E

Edisto Indians 49, 50, 51, 52, 69
Elliot II, William 109
English Civil War 29, 31, 32, 43, 44, 67, 84

F

Fabian, Peter 44, 45, 61, 63, 64
Florida 16, 39, 40, 43, 44, 46, 55, 63, 67, 78, 80, 85, 86, 89, 98
Fort Beauregard 111, 113
Fort Lyttleton 107
Fortune 17, 18
Fort Walker 111, 113
Fraser, Charles E. 114

G

Gascoigne, John 95, 96, 105
Georgia 40, 44, 51, 76, 77, 78, 80, 84, 85, 90, 92, 107, 114
Great Migration 19, 29
Greenleaf, Edmund 21, 22
Greenleaf, Sarah 21, 23
Guale 76, 77, 85, 86
Gulf Stream 45, 46
Gullah 110

H

Hancock, John 45, 64
Hilton, Edward 15, 19, 20
Hilton, Frances 21, 23
Hilton Head Island
 attacked by Union 113
 becomes part of St. Luke's Parish 104
 bridge 116
 British troops ordered to 107
 called Hiltons Head Island 89
 called Trench's Island 87, 96, 98

Index

Civil War 111
cotton grown 109
Dawsons, early inhabitants 94
forts constructed on 111
headquarters for the Federal
 troops and navy 113
houses 110
John Barnwell granted land 93
John Bayley granted barnoy 87
land for sale 98, 109
modern population and visitation 116
named by William Hilton 13
Native American occupation 79, 80, 86
plundered Revolutionary War 107
public auctions 102, 105
raids 108
shipbuilding 105
twenty-five families living there 1766 102
Union troops remain 114
William Clyde purchaes land 114
Hilton, Nowell 24, 118
Hiltons Head 13, 14, 56, 71, 75, 90, 96
Hilton, William
 becomes part owner of a ship 36
 castaways 51, 53
 childhood 15, 18, 19, 20
 children with first wife 21
 children with second wife 24, 119
 death 117
 death of first wife 23
 explores Cape Fear 39, 40, 42
 explores Cape Fear 1663 58, 61
 explores South Carolina 44, 48
 land grant 64
 letter from Captain Arguelles 55
 letter from Spanish 53
 letter to castaways 53
 letter to Spanish 54
 letter to William Davis 55
 marriage 21
 names Hiltons Head 56
 Native Americans kidnapped 61, 69, 71
 Native Americans South Carolina 49, 50, 51, 54
 returns to Barbados 61
 second marriage 23
 shop owner 38
 storm 58
 trades Indian slave 35
 trade with the West Indies 37, 38
 writing account of the expedition 62
Hilton, William Sr. 15, 16, 17, 18, 20, 21, 23
horses 29, 30, 83

I

indentured servants 29, 30, 31, 32, 33, 64
indigo 26, 31, 81, 99, 100, 101, 102, 105, 106, 116

J

Jamestown 15, 16, 17, 58

K

ketch 36, 37, 119
Kiawah 69, 72, 73, 76, 77

L

Laconia Company 19, 20
latitude 44, 46, 47
L'Estrange, Roger 63
Ligon, Richard 31, 32, 33, 34

INDEX

Locke, John 73
Long, Anthony 44, 45, 61, 63, 64
longitude 46, 47
Lords Proprietors 43, 44, 63, 65, 66, 67, 69, 73, 74, 81, 82, 84, 85, 86, 89, 96, 97
lumber 24, 82, 83
Lyford, John 18

M

Mackay, Alexander 93
Maine 16, 19, 20, 21
Martinangel, Philip 108
Massachusetts Bay Company 19
Mayflower 17
Miller, Simon 63
Mitchel Ormsby M. 113
Mitchelville 114
Mocama 76, 85, 86
Modyford, Thomas 44, 65, 78
molasses 28, 30, 34
Moon, Richard 63
Mosse, George 109, 110
Moultrie, William 106, 107

N

Nairne, Thomas 87, 91, 92
Netherlands 16, 88
Newbury, Massachusetts 21, 35
New England 14, 19, 21, 23, 24, 29, 31, 34, 35, 36, 37, 38, 39, 40, 41, 42, 44, 69, 82
New Hampshire 19, 20
North Carolina 16, 39, 40, 46, 58, 89
Northwich, England 15
Nowell, Increase 23, 24
Nowell, Mehitable 23, 24, 36, 117, 118, 119

P

Parris Island 13, 40, 49, 71, 72, 93
Pilgrims 16, 17, 18
Pinckney, Charles 98, 100
Pinckney, Eliza Lucas 99, 100, 101
Pinckney Island 72, 89, 93, 96, 98, 105, 111
Piscataqua River 19, 20, 21
Plymouth Colony 15, 16, 17, 19
Port Royal Island 87, 89, 107
Port Royal Sound
 1728 survey of 95, 105
 attacked Civil War 111, 113
 better than Edisto 72
 British ships blockade War of 1812 111
 explored by Robert Sandford 68, 70, 71
 French name 13
 Hilton leaves 58
 Hilton sails into 13, 56
 Kiawah better than 76
 lookout posts 89
 natural harbor 14, 56
 plans for settlement 67, 69, 74
 ships gathered in 1702 89
 Tybee captured in 97
 Westo Indians attack 75, 76
Portuguese 25, 27
Puritans 19, 20, 29

R

Revolutionary War 109, 119
rice 81, 97, 98, 99, 101, 106, 110

S

Sandford, Robert 68, 69, 70, 71, 72, 73, 75
Santa Elena 13, 40, 49, 50, 51, 52, 53, 54, 56, 76

INDEX

Savannah, Georgia 97, 98, 106, 107, 109, 110
Savannah River 72, 76, 84, 97
Scottish Presbyterians 84, 85
Sea Pines Plantation 80, 110, 114, 116
Shadoo 50, 51, 61, 69, 71, 77
shipbuilding 36, 104, 105
Skull Creek 72, 96, 105, 107, 108, 113
slaves, African 29, 30, 34, 65, 74, 98, 109, 110
 Barbados 28, 30, 32, 33, 34
 Hilton Head Island 102, 110, 111, 113
 runaway 93, 94, 103
 South Carolina 81, 97, 98, 99, 102, 107, 110, 111
slaves, Indian
 Barbados 30, 32, 33
 New England 35
 South Carolina 81, 83, 84, 86, 91, 98
 Virginia 76
St. Augustine 40, 49, 50, 55, 73, 77, 85, 89, 92, 93, 94, 97
St. Helena Island 87, 102, 111
St. Helena Sound 48, 83
St. Luke's Parish 104
Stoney, John 110
Stono Indians 51, 52
Stuart Town 85, 86, 87
Success 118
sugar 25, 27, 28, 30, 31, 64, 118
 Production 30, 34
sugar cane 27, 28, 30, 82
sugar mills 27, 28, 29, 30
sugar trade 14, 27, 30, 34
Surinam 37, 118

T

tabby 110
Talbird, John 108
Three Brothers 74, 77
tobacco 25, 26, 27, 29, 30, 31, 58, 81
Treaty of Madrid 78, 84
Trench, Alexander 87, 96, 98
Trench's Island 87, 94, 96

V

Vassall, Henry 65
Vassall, John 65

W

West Africa 34, 68, 98
Westo Indians 75, 76, 77, 83, 84, 85, 86
Winthrop, John 19, 21, 25, 26, 28, 29, 34
Wommony 54, 61, 71
Woodward, Henry 72, 73, 74, 77, 83, 84, 86

Y

Yeamans, John 65, 67, 68, 74, 75
Yemassee Indians 85, 86, 87, 90, 91, 92, 93, 94, 97

About the Author

Dwayne Pickett is a professional archaeologist and has a master's degree in anthropology from the College of William & Mary with a concentration in historical archaeology. He has been conducting historical research as well as excavations for over twenty-five years. He has authored or coauthored numerous reports and articles and is also the coauthor of *The European Struggle to Settle North America: Colonizing Attempts by England, France and Spain, 1521–1608*. In 2007, he co-founded Pickett Educational Resources LLC, which specializes in educational products and services that help bring history alive.

Visit us at
www.historypress.com